More Creative Lettering

TECHNIQUES & TIPS FROM TOP ARTISTS

Jenny Doh

LARK

New York

An Imprint of Sterling Publishing
1166 Avenue of the Americas
New York, NY 10036

ISBN 978-1-4547-0892-6

Distributed in Canada by Sterling Publishing
C/o Canadian Manda Group, 664 Annette Street
Toronto, Ontario, Canada M6S 2C8
Distributed in the United Kingdom by GMC Distribution Services
Castle Place, 166 High Street, Lewes, East Sussex, England BN7 1XU
Distributed in Australia by Capricorn Link (Australia) Pty. Ltd.
P.O. Box 704, Windsor, NSW 2756, Australia

For information about custom editions, special sales, and premium and corporate purchases, please contact Sterling Special Sales at 800-805-5489 or specialsales@sterlingpublishing.com.

Manufactured in China

2 4 6 8 10 9 7 5 3 1

larkcrafts.com

Contents

Introduction

After the success and popularity of *Creative Lettering*, I'm delighted to welcome you to *More Creative Lettering* — a book that shines light on alphabets and lettering projects that feature the signature lettering styles of our talented contributing artists. They are (in order of appearance): Lisa Congdon, Lindsey Bugbee, April Nemeth, Leandro Senna, Megan Wells, Diane Henkler, Roann Mathias, Kerri Winterstein, Kristine Lombardi, Alexandra Snowdon, Jenny Sweeney, Deborah Gerwig Powell, Rosaura Unangst, Michael Mullan, and yours truly.

In addition to the helpful techniques, you'll find an informative Basics section (beginning on page 8), along with helpful tips peppered throughout the book to inspire you as you journey through the exciting world of creative lettering. This excitement is largely related to the fact that anybody can be a hand-letterer. All you need is a piece of paper and pen. Or maybe a stick. Or maybe a piece of chalk. Or maybe any other thing that you probably have on hand that can be used to make letters in unique and imaginative ways.

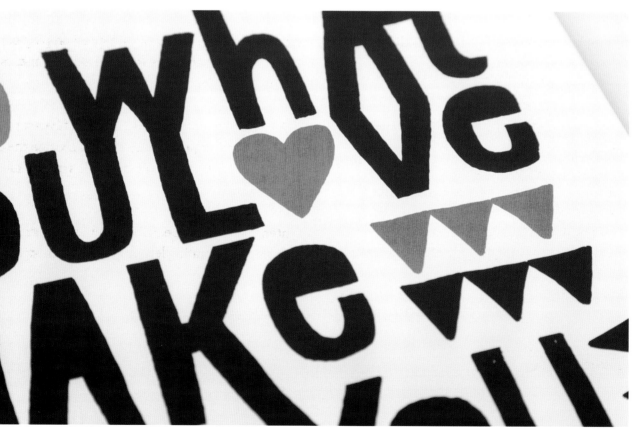

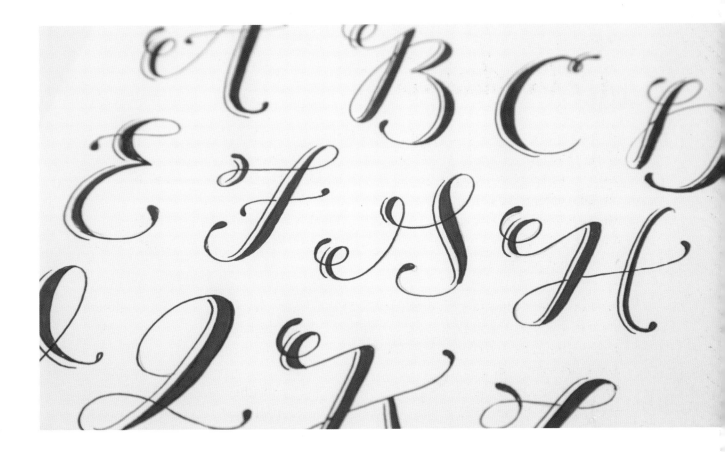

Through the fun projects shared by the contributors, you may be inspired to make unique wrapping paper, embellish seashells, make the silhouette of a ballerina or any other figure come to life, make ornaments with scraps of wood, and even make an alphabet with donut letters. Yes, donut letters.

This book is designed so you can flip to whichever page you want to and just begin. You don't have to start with the first project and go in order as they are presented. Whichever project inspires you most is the one you should start with. Undoubtedly, you will return again and again to this book to try the styles of all the contributing artists at a pace that you like and that works for you.

Thank you for joining us! You are in for a treat as the content presented on each page will surely help you develop your own lettering style and equip you with ideas for incorporating lettering into the creative facets of your life.

Jenny Doh

Basics

So much beauty and personality can be expressed through creative hand lettering. The art of lettering is especially attractive because you don't need much in the way of supplies to produce artfully composed alphabets. Even a scratch piece of paper and a pencil will do!

TOOLS AND MATERIALS

Even though few supplies are required, a variety of tools and materials are available. These will aid you both in creating your optimal work and in thinking outside of the box with regard to handwritten letters. Let's go over a few items that will be handy to have as you work on your own lettering projects and on the projects featured in this book.

Paper is the most common substrate (writing surface) for lettering projects. You can use hot-pressed, cold-pressed, or rough paper. Hot-pressed paper is the smoothest option, cold-pressed paper is slightly rougher, and rough paper has the most texture.

Once you've selected your paper, it's on to choosing the right writing utensil. Many artists find that it's easiest to sketch and create letters with a basic **#2 pencil** before adding ink, paint, or anything else that is more permanent. **Acrylic paint, gouache, chalk, chalkboard paint, enamel paint**, and **watercolor paint** are excellent options for adding color, while **permanent markers, chisel-tip markers**, and **gel pens** add permanency and vibrancy to your work.

If you're interested in a more traditional route and a calligraphy style of lettering, you can jump right into using a **dip pen** and **nibs**, or a **pointed pen** that you dip into a bottle of **ink**. **Gum arabic**, a liquid binding agent, is a great material to have on hand for traditional calligraphy because it allows you to mix inks and watercolors to control the thickness.

In addition to the foundational lettering tools, the projects in this book will often include steps to prepare a surface or complete a piece of art. For example, the white paint mixture **gesso** can be used to prime surfaces or add a muted effect to a finished piece. **Walnut ink** can be used to stain or darken paper. **Frisket** is a masking liquid used to protect parts of a project you don't want to add color to; once dried, it remains tacky and can be removed. **Rubber cement pickup** is a small piece of rubber that you can use to remove frisket, excess masking fluid, or rubber cement itself. You'll also want to have a **craft knife** on hand to trim any edges or cut pieces of paper; use a metal ruler or a wooden ruler with a metal edge to guide the craft knife as you're cutting, and do so carefully.

Some of the artists in this book use tracing as a technique to create their finished lettering pieces, so items such as a **light box** (or a well-lit window), **translucent paper**, **charcoal** or **chalk**, and **masking tape** are good items to have on hand for such instances.

ANATOMY OF A LETTER

Within the world of hand lettering, there are terms for the various parts of letter, as well as the spaces on the paper where the letters get created. For example:

The **cap line** (1) is the line above the mean line, where the upper portion of capital letters reach.

The **mean line** (2), also known as the "midline," is halfway between the baseline and the cap line.

The **baseline** (3), also known as the "writing line," is where the bottom portion of the letter rests, with the exception of the descender.

The **ascender** (4) is the portion of a lowercase letter that extends beyond the mean line.

The **descender** (5) is the portion of a letter that extends below the baseline.

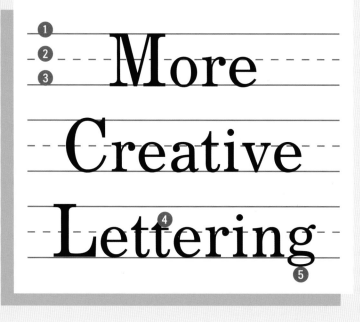

LETTERING TERMS

Before starting any of the projects in this book, it will be helpful if you understand a few terms related to creative lettering.

✳ A **font** is a complete alphabet that has been computer generated.

✳ A **style**, or **hand**, is a complete alphabet that has been produced through hand lettering.

✳ **Bold** letters are darker and thicker than standard letters, while **italic** letters slant to the right. **Cursive** letters join together, for words that flow with no space in between the letters.

✳ **Leading** is the amount of space between lines of words, measured from the base of a word on one line to the base of a word on the line below.

✳ A **downstroke** is a stroke created by moving a pen from the top of the letter to the bottom, using more pressure so it's thicker than other parts of the letter. An **upstroke** is formed by moving the pen from the bottom of the letter to the top, using less pressure so it's thinner than other parts of the letter.

✳ **Uppercase** letters are capitalized letters, while **lowercase** letters are not capitalized.

✳ The **baseline** is where the bottom of the letter rests; it's also known as the writing line. The **cap line** is where the top of uppercase letters rest. The **mean line**, or midline, is halfway between the cap line and baseline.

✳ **Ascenders** are the portions of lowercase letters that extend above the mean line, while **descenders** are the portions of letters that extends below the baseline.

✳ **Counter** is the enclosed or partially enclosed circular or curved negative space (white space) of some letters such as d, o, and s.

FONTS AND STYLES

What's particularly exciting about the art of lettering is the absence of limits. You can copy a tried-and-true font, you can create an entirely new style that no one's ever seen, or you can combine computer-generated fonts with handmade elements.

Before you think about creating your own font, it's best to understand the difference between serif and sans serif fonts. Serif fonts have small lines or curves at the end of each letter stroke. Times New Roman, Cambria, and Courier New are examples of serif fonts. Sans serif fonts don't have any details at the end of the letter stroke; Futura, Helvetica, and Arial are sans serif fonts.

TECHNIQUES

The artists featured in this book will lead you through the processes used to create their alphabets and projects, but there are a few techniques that are good to know before you get started.

Tracing

Utilizing tracing as a technique to create your lettering projects allows you to sketch your letters with pencil before finalizing them. Once you're satisfied with your sketched project, place a piece of translucent paper on top of it and use masking tape to secure the layers onto a light box or well-lit window before tracing.

If you don't have a light source, an alternative tracing method involves charcoal or chalk. Create your sketched project, rub charcoal or chalk on the back side of the project paper, place the project paper onto a new piece of paper with the rubbing side down, and retrace the letters to leave an imprint on top of the new paper.

Lettering with Chalk

Working with chalk adds a lovely dimensional element to any lettering project, but it can be tricky to work with. To achieve the best results with chalk, sketch your design on paper first. Then "cure" the chalkboard surface — either an actual chalkboard or a surface that has been painted with chalkboard paint — by rubbing chalk lightly over the entire surface. Also rub chalk on the back side of the paper sketch, then place the paper sketch on the chalkboard, with the rubbed side down. Trace over the sketch with pen or pencil so the chalk from the paper leaves a light imprint on the chalkboard, then go back over the imprint with actual chalk to fill it out completely.

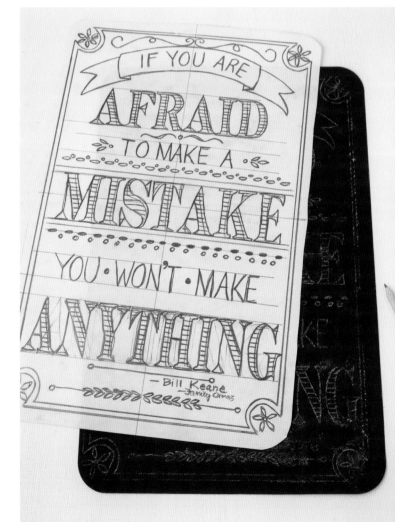

Adding Color Using Photoshop

Some artists featured in this book sketch designs using pencil and/or pen, then use Photoshop rather than paint to add the color. To do this, sketch your design in pencil first before going over the sketch with pen. The darker you make the lines of the sketch, the better they'll show up in a scan. Then follow these steps:

1 Scan your image, open it in Photoshop, and choose the appropriate size.

2 Go to Image>Adjust>Brightness/Contrast to make the white parts ultra white and all the lines ultra black.

3 Duplicate the background image, then create a new layer underneath the background copy.

4 In the Layers box, click Multiply.

5 Hide the original background layer, then color the image on the new layer using the paint tool. As long as the painted layer remains underneath the background copy, the paint will show up with the sketched lines.

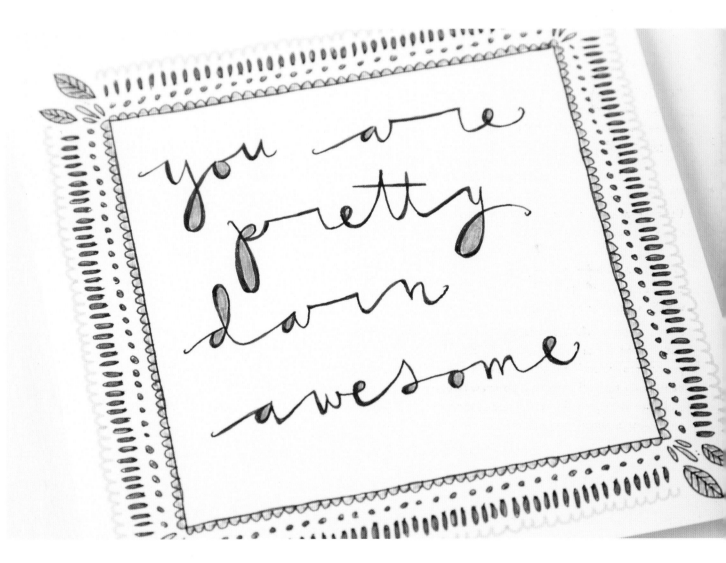

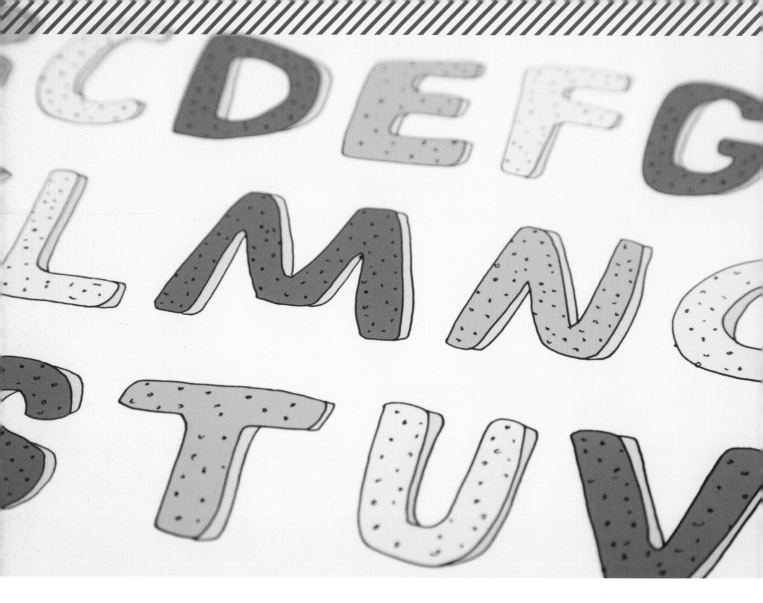

Lisa Congdon

www.lisacongdon.com

I have always been drawn to lettering as an art form. In 2012, in order to get better at lettering, I embarked on a project called 365 Days of Hand Lettering in which I hand lettered something (mostly quotes) every day for the whole year and posted the results daily on my blog. Through this experience, I practiced religiously and played around with different inks and nibs and pens to see which I liked best. Eventually I developed my own hand-lettering style that I would describe as clean and modern with unique quirks.

FAVORITE WRITING INSTRUMENT

I letter with Micron pens. I love their sturdy and long-lasting tips.

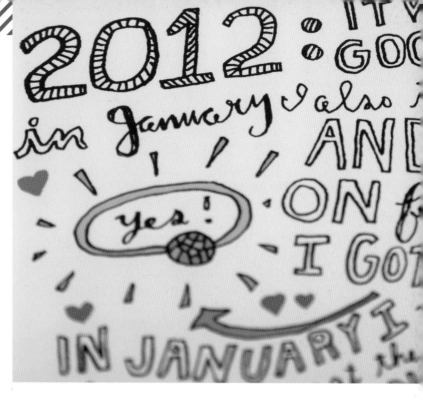

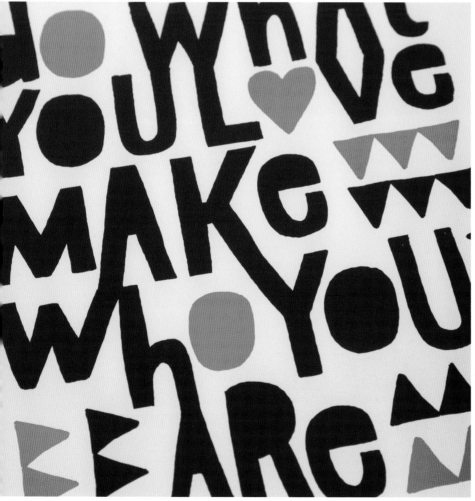

FAVORITE LETTER

I love drawing capital R's. It is one letter that has a straight line, a diagonal line, and a curved line, so there are many opportunities to make it look really cool!

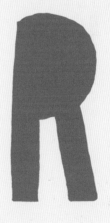

Donut Alphabet

Donut letters are really forgiving because they look great, even with all of their uneven imperfections. There are hardly any other letters that are as much fun to make.

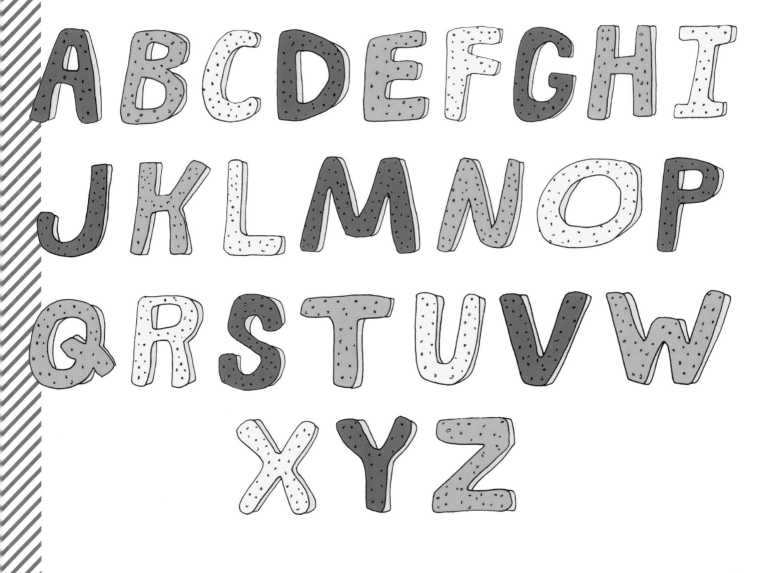

fig. A

fig. B

fig. C

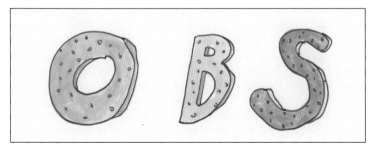

fig. D

What You'll Need

* White heavyweight paper
* Pencil
* Black fine-point permanent marker
* Eraser
* Watercolors (or colored markers)
* Small paintbrush

Method

1 On heavyweight paper, use a pencil to lightly draw the outline of letters in a chunky, slightly wonky, and sans serif manner **(A)**.

2 Draw thin down-stroke lines to the right of each section of each letter to add dimension **(B)**.

3 Draw tiny dots or circles to make "sprinkles" **(C)**.

4 Trace the drawings with the black fine-point black marker.

5 Erase any stray pencil marks.

6 Using watercolors and a small paintbrush or colored markers, color the main section of the letters with colors that remind you of donut icing, such as pink, yellow, and brown. Color the dimensional sections with a light beige **(D)**.

two donut pieces

For these pieces, I drew the letters with a pencil and then traced over them with a pen, as explained in the methods for the donut alphabet (page 15). On the Donut You Love Me piece, I made small scallop shapes at the top of the letter O to make it look like someone took a bite out of the letter. For the piece with the quote by Matt Groening, I made donut letters for the first word and then simple line letters for the rest of the quote. I also drew two large donuts at an angled perspective. Rather than using watercolors to color these pieces, I scanned them and then colored the donut letters and donuts on my computer using Photoshop (see page 11).

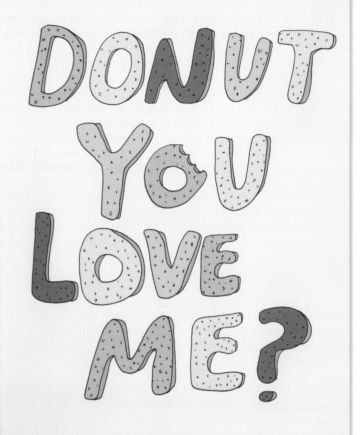

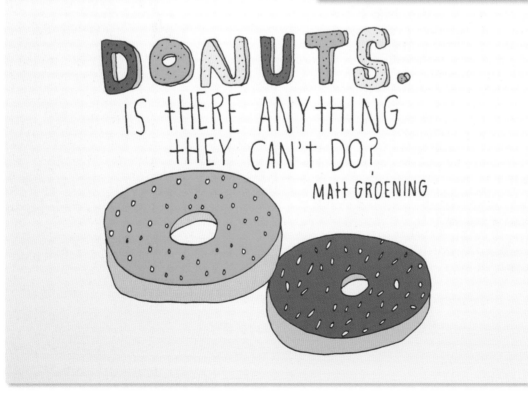

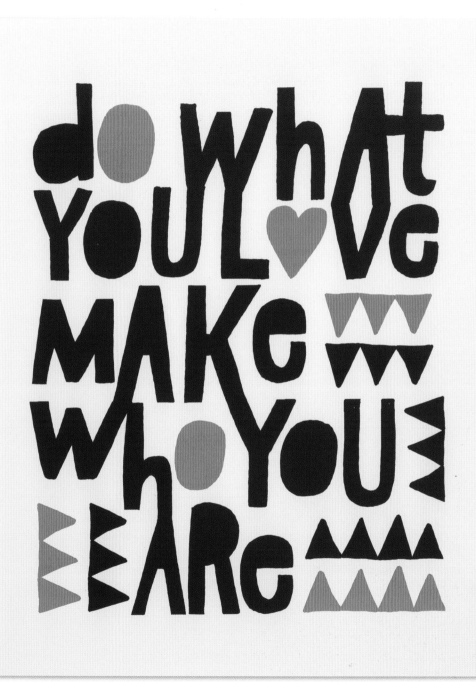

This was a piece I did to benefit the Makeshift Society Coworking space in San Francisco and Brooklyn. It is the first lettering piece I made wherein I used my signature block lettering, but connected the letters in interesting and unexpected ways. To letter words in this style, sketch out the words using block letters without serifs, combining uppercase and lowercase letters. Connect letters where it feels natural for you, and fill in small captured spaces in letters that have such spaces, like Ds, Os, As, and Ps. Add small shapes, such as triangles and hearts, and add a pop of red to some of the letters and shapes with a colored marker or by scanning the work and using Photoshop.

I made this piece at the end of 2012 to highlight all the things that happened for me that year. It is a good example of freeform lettering that doesn't follow any particular rules! You can combine block letters with swirly and plumped-up letters, and add tiny doodles in between certain words until the entire page gets filled up. Start at the top of the page by lettering and doodling things that you want to highlight from the month of January and then work your way down all the way to December.

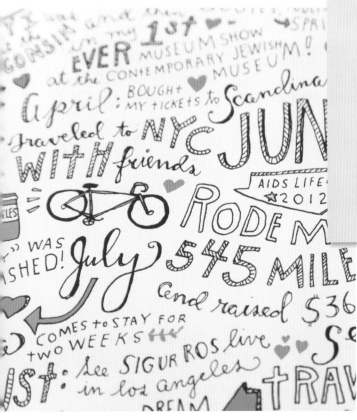

The title of a speech that I recently gave at a conference was "Embrace the Abyss." I made this piece for that occasion by first creating a concentric circle design with a black fine-point marker, starting with a tiny circle at the center of the paper. I then drew a continuous swirly circle from that tiny circle, adding lines that connect circle to circle. Once the entire page was filled, I drew simple block letters with a pencil and then traced over the letters with a black fine-point marker. I scanned the work and then filled in the large block letters in red using Photoshop.

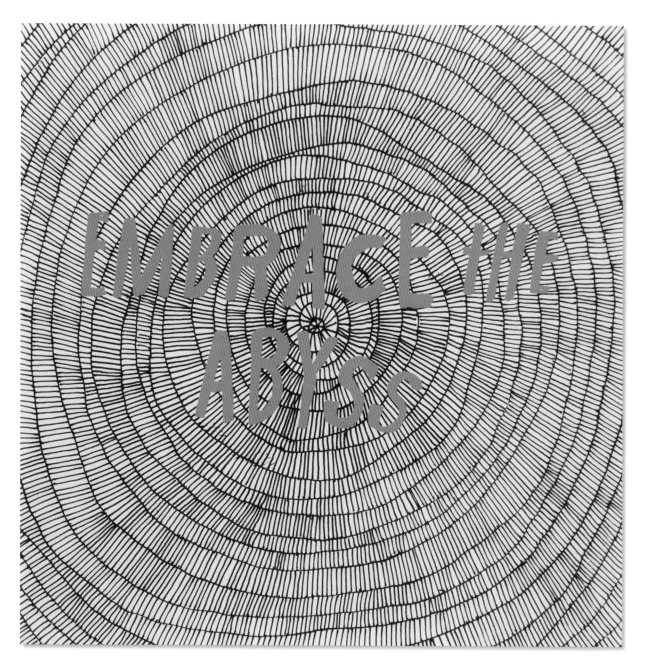

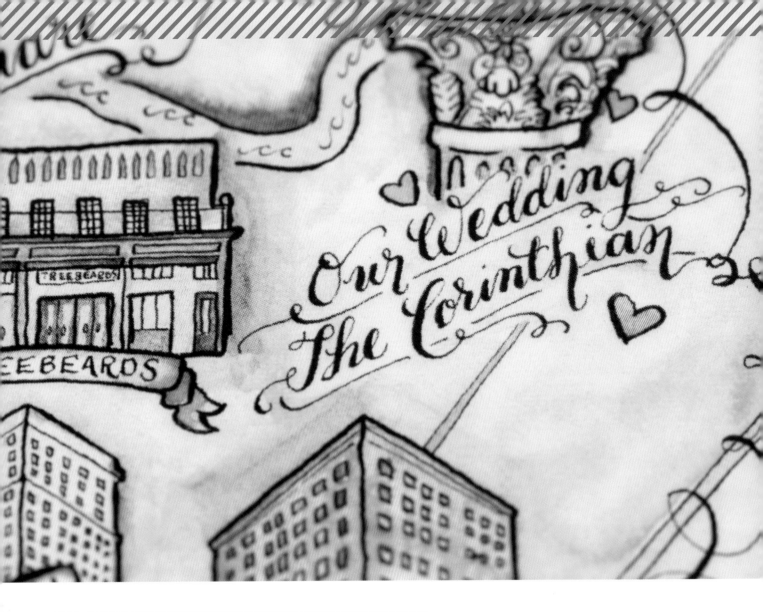

Lindsey Bugbee

www.thepostmansknock.com

All I remember about hand lettering in my childhood was the jealousy I felt looking at adults' handwriting. All of my teachers had such lovely cursive handwriting, and of course as a little girl I couldn't keep a pen that steady! I had the same art teacher from kindergarten to my senior year of high school, a very talented woman named Donna Roberts. She paved the way for me to utilize offbeat techniques in my lettering endeavors.

FAVORITE LETTER

I like the capital script letter F because it has lots of flowy possibilities!

FAVORITE WRITING INSTRUMENT

I have never met a writing instrument that I didn't like. My favorite one right now is probably my straight cork calligraphy pen with the Brause "blue pumpkin" nib.

Faux Calligraphy Alphabet

Faux calligraphy is a great way to kick off your understanding of how to create "real" calligraphy. By filling out certain areas of the letter so they're thicker than the rest, you develop an understanding of when to apply and let off pressure when using a calligraphy pen. You begin to understand how the curves and lines work with each other to form letters. The best part is that anyone can create it!

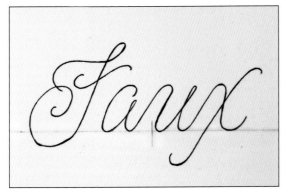

fig. A

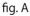

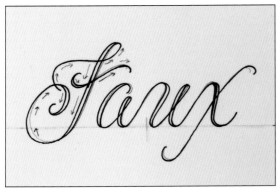

fig. B

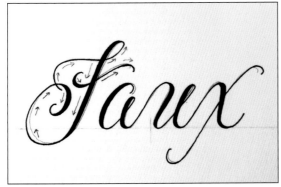

fig. C

fig. D

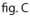

What You'll Need

* White heavyweight cardstock
* Pencil
* Ruler
* Black gel pen
* Eraser

Method

1 On cardstock, use a pencil and ruler to lightly draw a straight horizontal lines that can serve as the guide to your letters. Using this alphabet as a reference source, use the pencil to write the basic script letterforms of a word on that line. Go over this with the black gel pen **(A)**.

2 Use the pencil to draw extra parallel lines approximately 2 mm to the left of all of your downstrokes. Go over these parallel lines with the black pen **(B)**.

3 Fill in the space between the parallel lines and the downstrokes with the black pen **(C)**.

4 Let your ink dry *completely* before you erase any visible pencil marks. Gel pens are like nail polish: you may think the pen work has dried but you will get a nasty surprise when you apply any pressure to it or brush against it. It's best to wait several hours to let the ink completely dry (**D**).

Negative Space Letter

To make this project, brainstorm special experiences, inside jokes, and locations that you share with the intended recipient. You'll crowd those words around the outline of the initial of the recipient to make the initial appear as the negative space.

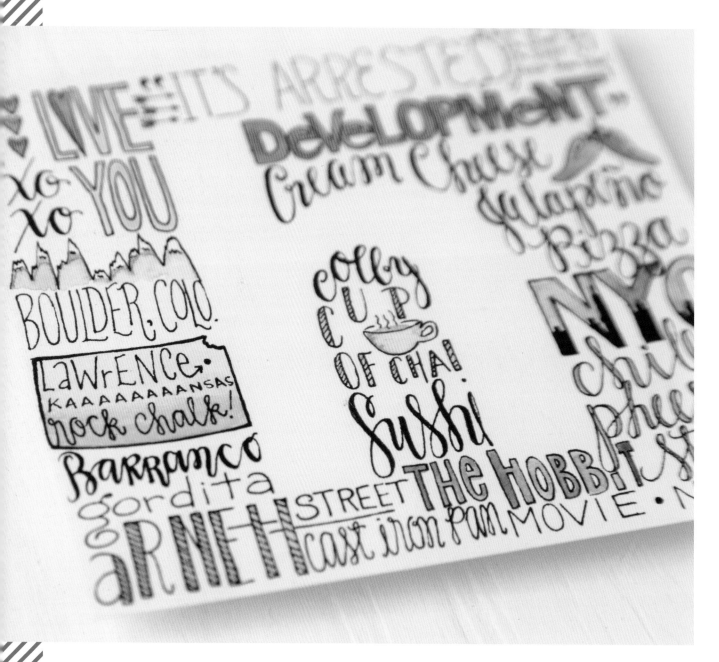

fig. A

fig. B

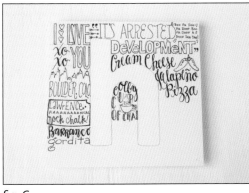

fig. C

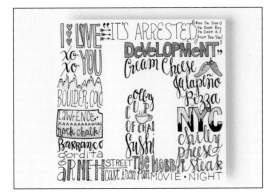

fig. D

What You'll Need

* Pencil
* White heavyweight cardstock, 5 inches (12.7 cm) square
* Stencil (optional)
* Black gel pen
* Colored markers and pencils
* Eraser

Method

1 Make a list of special words that you want to use for this project.

2 Lightly draw a letter freehand onto your cardstock. If you have a letter stencil, you can use the stencil instead of drawing freehand. If you don't have a stencil and really want to use one, simply print a Word document with a letter set in a large size, cut it out, and trace around it **(A)**.

3 Using many different lettering styles, pencil in the words from your list around the traced letter. You may use a ruler to ensure straight writing if you wish. Feel free to experiment with small doodles by adding things like mountains, hearts, and even little green peppers! Draw and fill in with letters and doodles until you have filled up the entire space surrounding the letter **(B, C)**.

4 Go over the penciled-in letters and doodles with the black gel pen. Add color to some of the words and doodles with colored markers and pencils **(D)**.

5 Allow the ink to fully dry (several hours is best), and then erase your pencil marks with an eraser.

Ombré Watercolor Love

I love this project because it's so versatile. Whether you're writing a letter, working in your sketchbook or scrapbook, or even making promotional materials for your business, you can implement this technique! I've used pink, red, and orange tones for this project; but you can experiment with different colors that you like.

love

thepostmansknock.com

fig. A

fig. B

What You'll Need

* Watercolors
* Palette to mix watercolors with water
* Small cup of water
* Watercolor paper
* Pencil
* Ruler
* Tiny hairline brush
* Eraser

Method

1 As an optional first step, use the faux calligraphy alphabet method (page 22) to practice the word you would like to make in this ombré style.

2 Mix a diluted solution of your main color. My main color was red, so I mixed red with a lot of water to make a pink. The reason you want this to be diluted is because this is the color that will show up at the top of your ombré letter, so you want it to be the lightest color.

3 On watercolor paper, use a pencil and ruler to make a horizontal line to guide your lettering.

4 Write your intended word on the watercolor paper using the diluted color. There should be no variation in line thickness **(A)**.

5 As quickly as possible after writing the word, fill in the downstrokes with an additional stroke of that diluted color. Try to blend it as best you can **(B)**.

6 Pretend there is a line dividing the bottom of the word from the top of the word. Go over the bottom part with a much darker concentration of your main color (using less water) **(C)**.

7 Pretend there's another line dividing the middle of the word from the top of the word. Fill in this area with a mid-tone watercolor. For this word, I chose orange.

8 Blend in the mid-tone by dipping the brush into a little bit of water and teasing out the edges of the orange until they blend in with the rest of the word **(D)**.

TIP

For a colorful rainbow effect, use this method to make each letter of a word in distinctly different colors.

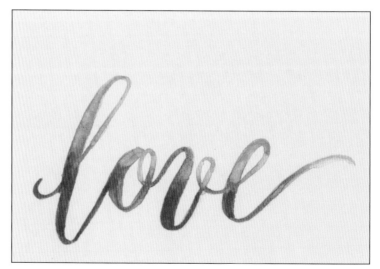

fig. C

fig. D

Through my company, I am constantly designing materials for weddings. One of the pieces I most enjoy creating is illustrated and lettered maps. Once you have the basic outline of the map drawn, you can add lettering and doodles to bring personality to the map. Keep it simple by leaving the map black and white, or add color with watercolors, markers, or pencils. I also enjoy creating wedding invitations which can be made by first deciding on the size and placement of all the words that need to go onto the piece. Once that's done, you can use a calligraphy nib with holder to letter the invitation — or use a plain black pen and the faux calligraphy method. The interior pieces can be reproduced at professional print shops, but I highly recommend hand-lettering the envelopes. When using dark envelopes, try using white ink to make the lettering pop!

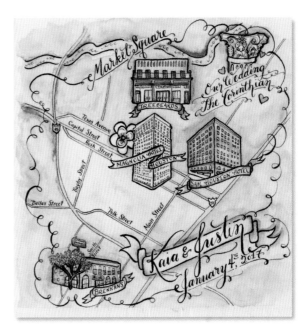

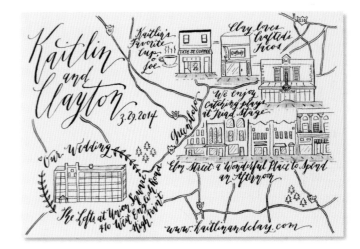

April Nemeth

www.littlekorboose.com

My earliest memories of hand lettering are from handwriting class in the sixth grade. I remember loving the old handwriting paper and studying each letterfom to get everything perfect. It was love at first sight. I also remember my father's perfectly lettered ledger. I watched him write a lot.

I remember thinking he had stamped the letters in the ledger because they were so perfect. I studied that as well and wondered how he got it that way. The answer, of course, was that he practiced.

FAVORITE LETTER

I like the letter A. I know it the best because it is the first letter of my name. I've been writing it for a while. I also like a good uppercase B and uppercase R.

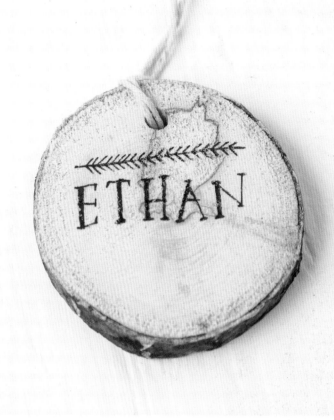

FAVORITE WRITING INSTRUMENTS

I love how thin and small I can draw with the Pigma Micron marker, size .005. The BIC 0.5mm #2 mechanical pencil and also the Staedtler Lumocolor permanent pen (fine nib) are also favorites of mine because I can write hard and super thin with both of them.

Positive Affirmation Wrapping Paper

I've been known to send hand-lettered positive affirmation notes to family and friends. Hand-lettered affirmation wrapping paper is a next-level version of the note. Create your own and include all of your favorite sayings, to make a friend or family member feel extra special! I truly believe that the art of gift-wrapping is a way to communicate our intent and thoughtfulness.

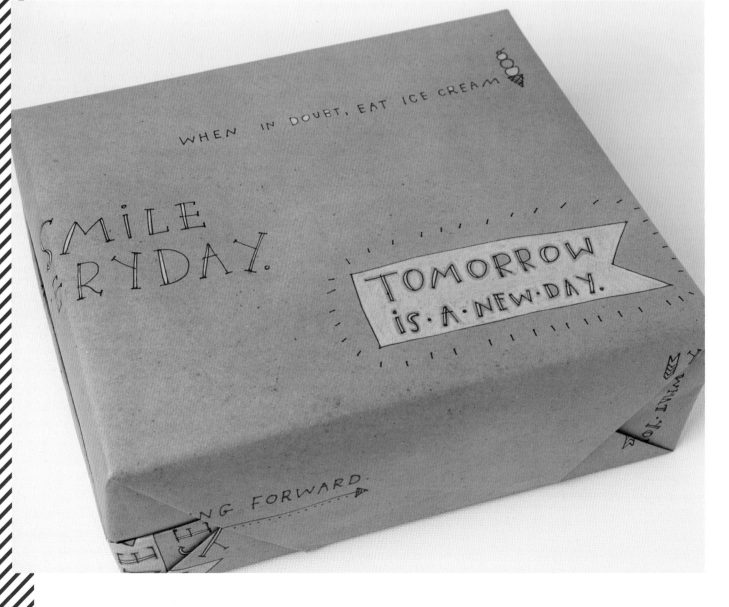

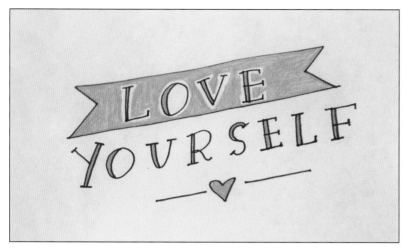

fig. A

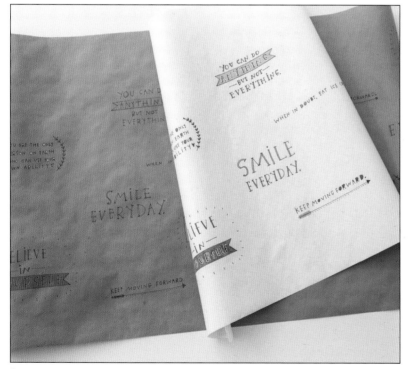

fig. B

What You'll Need

* Sketchbook
* Black fine-nib permanent marker
* Roll of craft paper, 30 inches (76.2 cm) tall
* Roll of white paper, 30 inches (76.2 cm) tall
* Chalk pencils in assorted colors
* Low-odor, non-toxic spray fixative

Method

1 Choose/create a series of positive affirmations to include on the gift wrap and sketch them out in a sketchbook **(A)**.

2 Use the sketches as a reference as you letter the affirmations with a black marker in a repeat pattern on a roll of craft paper, and then a roll of white paper. A repeat pattern can be planned out so that it occurs every few inches in the same location, or it can be more random and repeat every now and then in different locations on the paper.

3 Add color to the black line work with chalk pencils **(B)**.

4 In a well-ventilated area, spray the papers with a fixative so that the chalk pencils will not smear.

Booth Postcard

This postcard is one I made as a marketing piece when I was showing my work at a stationery show in New York. By making the entire piece with my hand lettering, I felt that the postcard had a much more authentic and interesting feel to it.

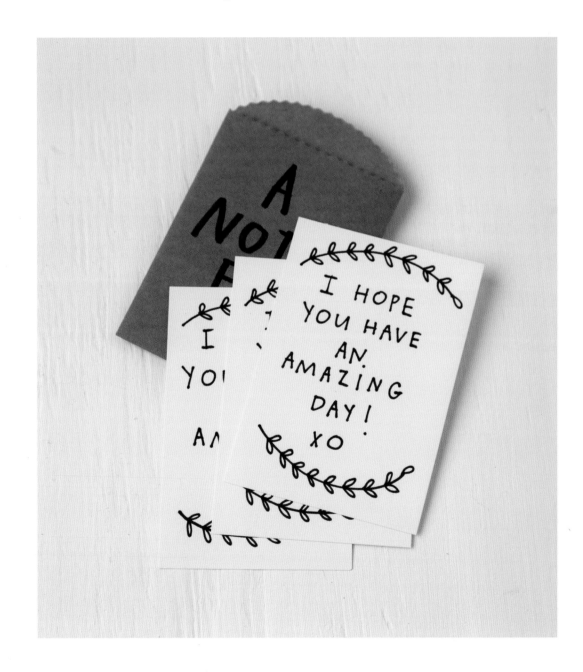

What You'll Need

* Mechanical pencil: size 0.5 mm
* Translucent tracing paper
* Eraser
* Black fine-point permanent marker
* Scanner and computer with Photoshop
* Printer that accepts cardstock (or a professional printer)
* Kraft-colored cardstock
* Sharp craft knife
* Ruler

Method

1 Use a mechanical pencil to sketch out the postcard design on tracing paper. Erase and re-sketch parts as needed.

2 Place another piece of tracing paper over the sketch and trace it with a black fine-point marker.

3 Scan the finished piece and then clean up the scan on your computer, using Photoshop.

4 Using cardstock, print out the finished design on your printer and trim to size with a ruler and sharp craft knife. If your printer does not allow you to print cardstock, take the scan to a professional printer to get it printed.

QUIET FOCUS

One lesson I've learned in terms of lettering is that it's personality, not perfection, that brings letters to life. Also, I have learned that I like to work in a quiet space. Quiet, focused work is a form of meditation for me, where I can cultivate my style.

Using an unexpected substrate is a fun way to make hand lettering even more special. I made this alphabet on a thin sheet of wood veneer using my signature block letters that I drew with a standard black permanent marker. I added simple closed counter form strokes to the letters and filled those closed spaces with a yellow chalk pencil. To prepare for the letters, I sketched them out in a sketchbook and used that sketch as a reference, but did not do any sort of pre-pencil work or transferring or anything like that. I just went for it, pen to wood veneer!

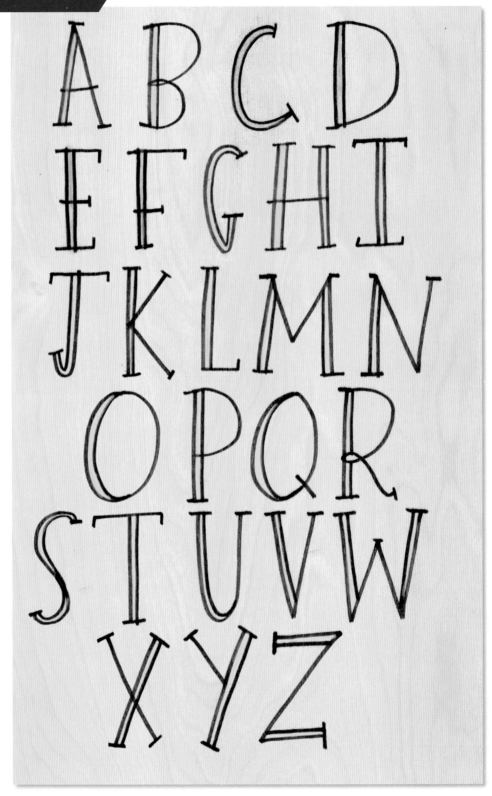

Sending letters or cards is a way I visually communicate and connect with people. I approach this type of correspondence almost as if it were a mini design project, carefully selecting the paper and envelopes. I am always sure to make the person's title or store name on the envelope the largest, and I incorporate a drawn element to emphasize the recipient even more. The zip code is always large with wide kerning, which means that the numbers are spaced farther apart rather than close together.

The envelopes I addressed for this project happen to be four of my favorite places in my hometown. I first sketched thumbnails of the envelopes in my sketchbook and used the sketches as a reference as I lettered directly on kraft envelopes with a black fine-nib permanent pen.

lettered wood gift tags

I bought these cut pieces of wood from an online store. If you can't find cut wood online or at a store, you could just use found wood and cut it into small pieces. If it is too rough, sand a smooth area on the wood where you will do the lettering. To make my tags, I used a black extra-fine permanent marker to letter names with uppercase block letters like the ones shown in my alphabet. After making the closed counter form strokes, I filled in the closed spaces with the black marker rather than adding color. Above each name I doodled a simple twig design, starting with one long horizontal line, followed by small angular lines to make it look like a piece of foliage from nature. I used a small hand drill to make holes at the top of each name and then pulled hemp twine through the holes to create ties. You can use these tags to adorn gifts or decorate a tree. So cute!

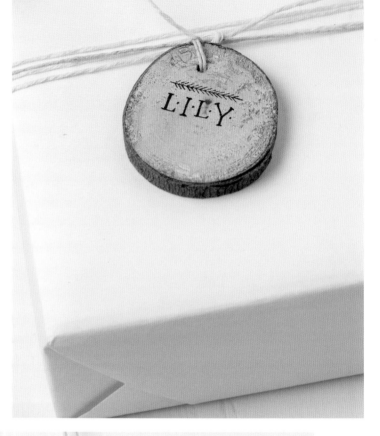

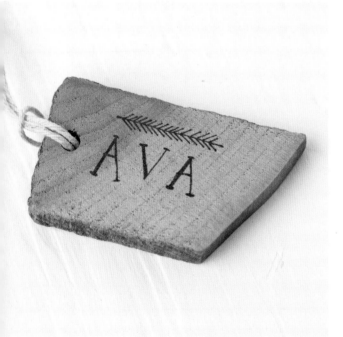

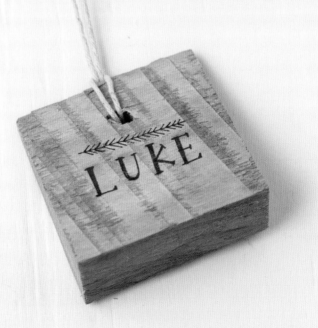

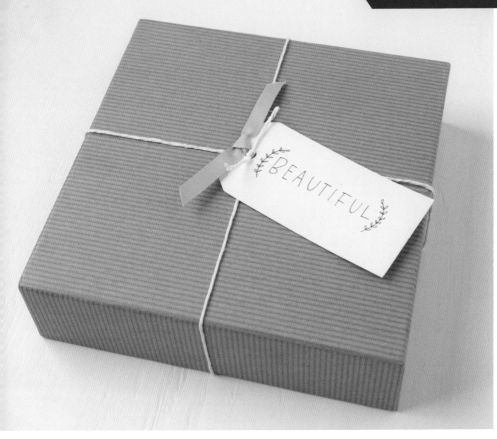

This project is special because it is a way of personalizing a gift. You can include a hand-lettered positive attribute tag with a gift to make the recipient feel extra special and to really communicate how you feel about them. I simply use a black extra-fine marker to letter a word on a shipping tag in all capital letters without any closed counter form strokes. Once the word is lettered, I usually add a hand-drawn graphic element with the same black marker. Then I finish by adding a piece of colorful ribbon for a pop of color!

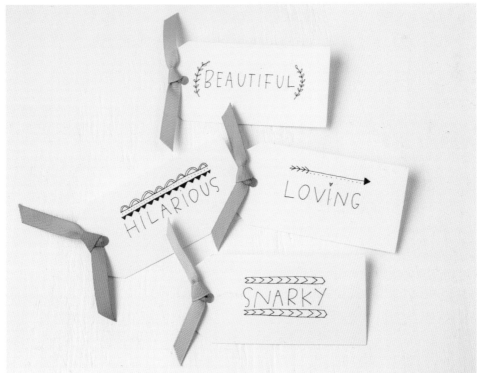

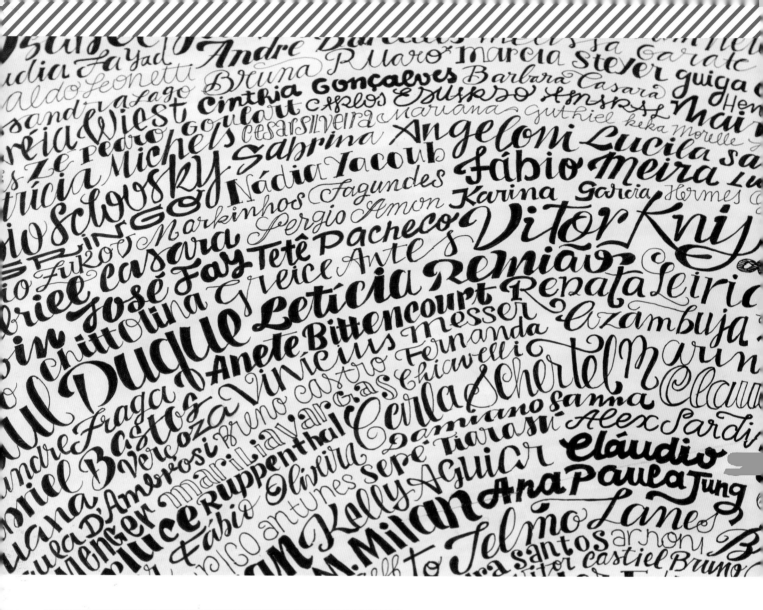

Leandro Senna

www.leandrosenna.com

Typography has always fascinated me, but it was just recently that I came to that realization. Since I was a child I loved to draw. I remember doing all of the display cards for my classmates for every project. I also liked to design their names as a gift and completely fill my book pages and desks with letters, which used to drive my teachers insane. My mom has always acknowledged the value of my lettering projects and experiments and has held on to many of them over the years.

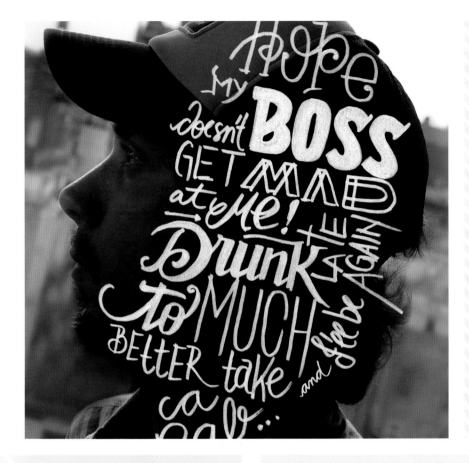

FAVORITE LETTER

I love ampersands. I don't have a favorite letter but I am always drawing the letter S, which is my initial.

FAVORITE WRITING INSTRUMENT

My favorite writing instrument may be the pencil, because it's the tool I use in order to think. I always start my projects with a pencil and sketchbook.

Images and Words

Everywhere we go, we are surrounded by people, each one with their own story. This artwork, through photos and handmade typography, imagines these stories, based on details such as their clothing, accessories, environment, and attitudes.

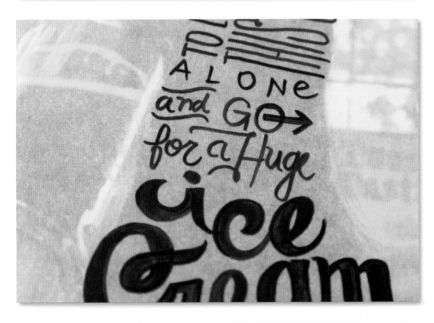

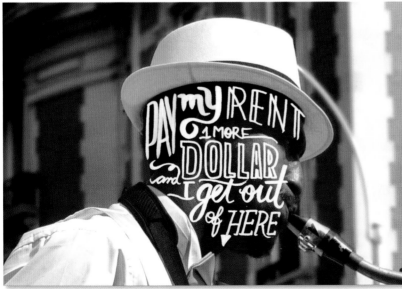

What You'll Need

* Translucent paper
* Prints of photos (I used portraits but you could use photos of anything)
* Pencil
* Black fine-point marker
* Eraser
* Scanner
* Computer with Photoshop
* Printer

Method

1 Place the translucent paper on top of the photograph and use a pencil to make letters and words inspired by the photograph.

2 Use a black marker to trace over the pencil work. Once dry, erase any stray pencil marks.

3 Scan the lettering into your computer and use Photoshop to fuse the scanned letters on top of the corresponding photograph. Change the color of the lettering from black to white.

4 Print out the finished piece.

I recently moved to San Francisco and initially thought about designing a Victorian-style alphabet, inspired by some old San Francisco documents I found in books and by the amazing architecture spread throughout the city. I started looking for a design that could mix all the Victorian charm with a touch of modernity. After some sketches, I reached this interesting result. I used a bold Bodoni (a series of serif typefaces first designed by Giambattista Bodini) as a structural base and traced all the letters over. Then using a light box, I redid the lines on paper. I really like the empty spaces and the thin lines. The little dots in the middle line add movement, as though that line were floating.

Naming this alphabet probably took more time than actually designing the letters. I picked up the letters I like the most: M S T Y and looked for a word to represent my idea. San Francisco is also known as The Fog City, and so I decided that MISTY is a special way to say that.

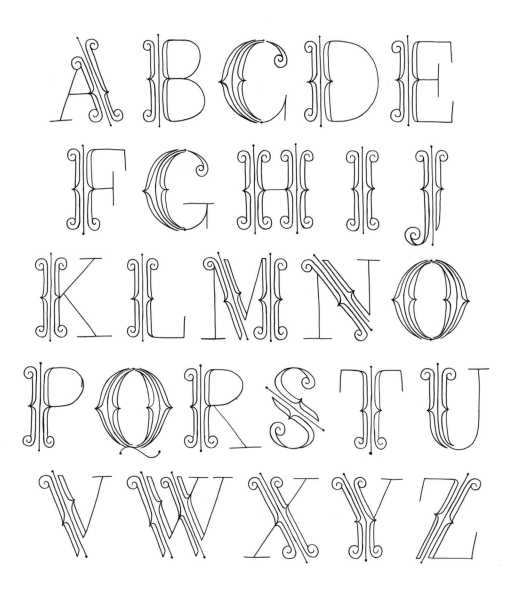

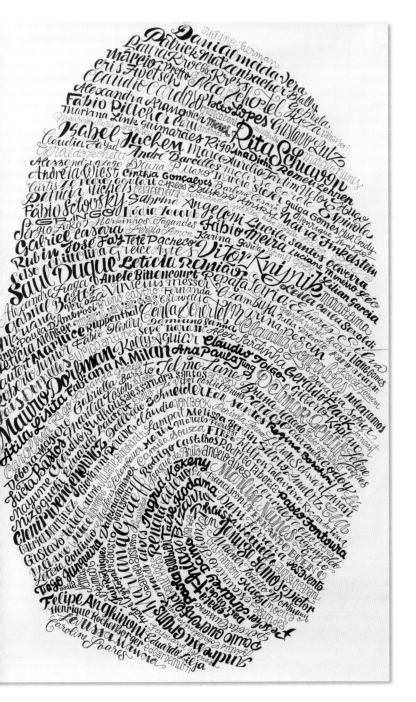

DEZ Comunicação, an advertising agency from Brazil, celebrated their 20th year anniversary in 2013. As part of the celebration they wanted to pay tribute to all the people who worked there through the years (and literally left their marks/fingerprints there).

They commissioned me to design four posters, writing their employees and former employees names over the fingerprint image from the four partners (Carlos Saul Duque, Juliano Weide, Audrey Damo, and Kelly Aguiar). The whole project took me about one year (!) from first contact: identifying names, doing pencil drawings, getting approvals, making adjustments, adding black marks over the pencil drawings, and completing the final digital treatment.

To make each poster, I got each partner to give me their fingerprints and I used Illustrator on my computer to divide the image among four tabloid pages; tabloid is a term for a paper size that measures 11 x 17 inches (27.9 x 43.2 cm). I printed the fingerprint in very light gray and taped the four pages together to make one large piece.

Using a pencil, I drew all the names of current and former employees along the light gray lines of the fingerprints. I went over the pencil marks with a black marker and then erased any visible pencil marks. I scanned the entire poster and then used Photoshop on the computer to remove the gray fingerprint beneath the lettering and to do other cleaning and tightening up.

Inspired by Bob Dylan's "Subterranean Homesick Blues" video, where he flips cards with the lyrics as the song plays, I decided to re-create those cards with handmade type. I ended up doing all the lyrics, and not just some of the words, as Dylan did. I did 66 cards done in one month during my spare time using only pencil, black tint pens, and brushes. The challenge was not to use the computer—no retouching was allowed. Getting a letter wrong meant starting the page over.

There aren't instructions for any of these cards, really. I was just doing, practicing, trying—no thinking. I didn't like many of them, and found some mistakes later, but I didn't do it again. My goal was research and practice. Here are six cards from the set.

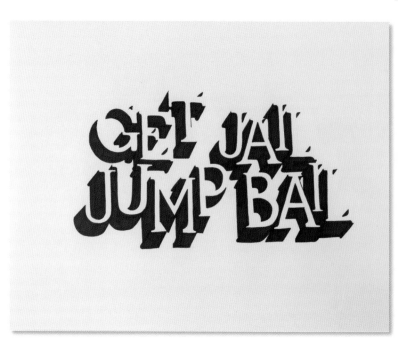

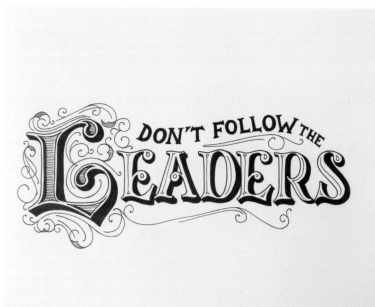

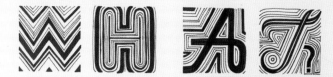

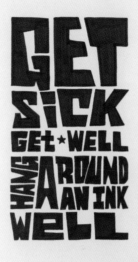

THE MOST AND BEST

Beginning letterers may experience frustration at first. But in my opinion, you really can't go wrong. Handmade means imperfection and that imperfection is the charming detail of hand lettering. You have to find your style through practice and then learn how to get the most and best from your style.

BETTER
STAY
AWAY
FROM
THOSE

Megan Wells

www.makewells.com

In middle school and high school, I used to carry around this huge case of Crayola markers and I'd make posters of my friends' names for them to hang in their lockers. I was always trying to make my notes in class look pretty, and I'd focus on writing pretty to force myself to take notes and not space out. But it wasn't until about two years ago that I really started working on my style and craft with any sort of discipline.

I can't say that I loved it right away, but I loved the way the finished lettering looked. It took a while for me to begin enjoying the process. Once I began improving, the possibilities of what I could do with letterforms began to expand. That's when the process became fun for me.

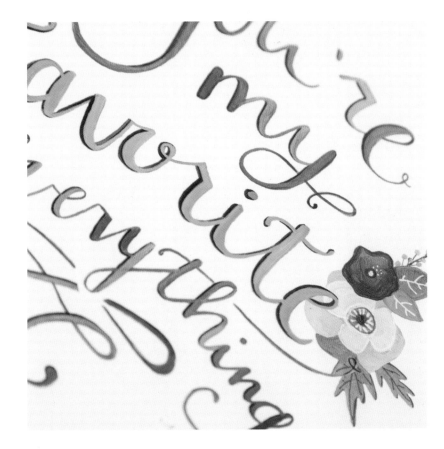

FAVORITE LETTER

I love writing the letter M. Yes, it's the first letter of my name, but I also think that it has so many possibilities. I've found many ways to write and draw the letter M.

FAVORITE WRITING INSTRUMENT

I love Uni-Ball Signo Gel pens. They write super smooth and fluid. The white ink is the most opaque that I've found. It's my go-to pen for sure!

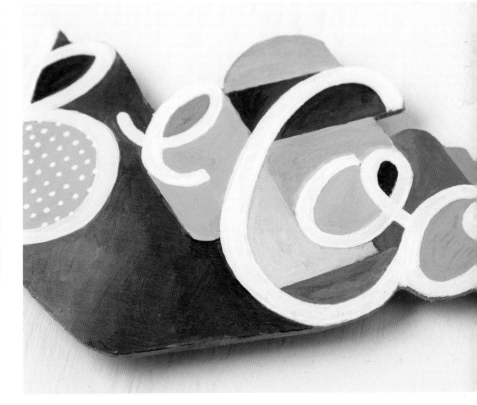

All is Well Alphabet

This alphabet is whimsical and elegant at the same time, which is how I would describe my work as a whole. It can be formal and playful, fancy and quirky.

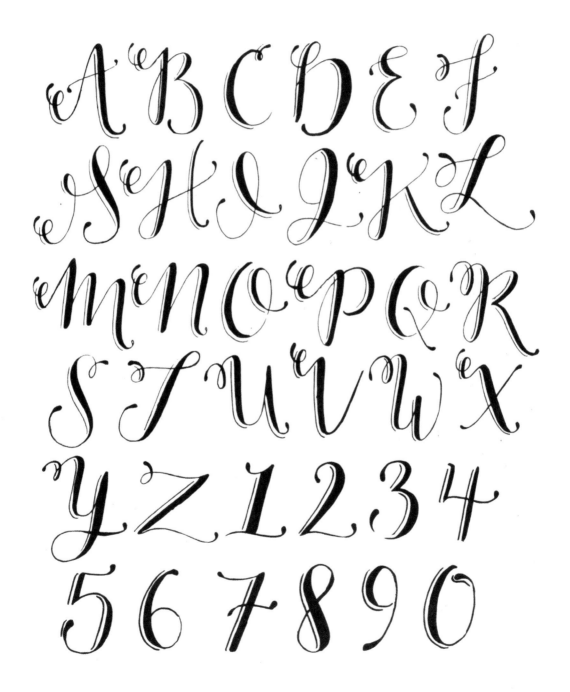

fig. A

fig. B

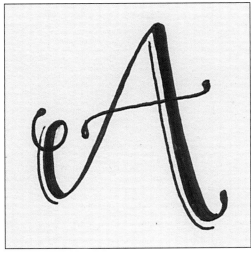

fig. C

What You'll Need

* White heavyweight paper
* Black fine-point pen
* Optional:
 - Mechanical pencil
 - Fine paintbrush
 - Fluid acrylic paints
 - Palette
 - Water
 - Eraser

Method

1 On white heavyweight paper, draw the main body of each letter using a black pen, adding swirly serifs to each end **(A)**.

2 Thicken the down strokes of the letter and keep the upstrokes thin. Make all ends look rounded by plumping them with the pen **(B)**.

3 Draw a thin line to the bottom left of your down strokes to create a simple drop shadow **(C)**.

COLOR OPTION

To make these letters colored instead, follow steps 1 to 3 but using a mechanical pencil. Paint the letters using a very fine paintbrush and fluid acrylic paints. Water down the paint to create a faint wash as your drop shadow. Let the paint dry completely before erasing any remaining pencil marks.

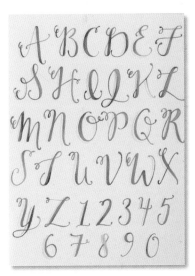

Doodle Letter Silhouette

I love to doodle flowers and floral patterns, which tend to be more on the girly side. This project combines that with my love for using the shapes as letters in my art.

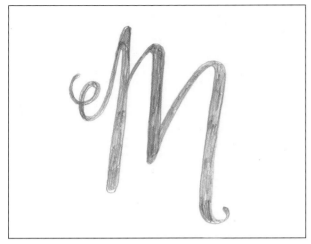

fig. A

fig. B

fig. C

What You'll Need

✴ White copy paper
✴ Mechanical pencil
✴ White heavyweight paper
✴ Watercolors
✴ Water
✴ Small paintbrush
✴ Eraser
✴ Gel pens in assorted colors
✴ Colored pencils
✴ Water-soluble graphite pencil

Method

1 On a piece of white copy paper, use a mechanical pencil to sketch out your letter of choice. I made an M in script but you can use any letter you like, with or without serifs. Thicken or plump your letter, making the lines at least ⅛ to ¼ inch (3 to 6 mm) thick. This doesn't have to be super neat because it's just going to be your example **(A)**.

2 Using your sketch as your guide, use a mechanical pencil to draw the outlines of your letter very, very lightly on the heavyweight paper **(B)**.

3 Using watercolors and a small paintbrush, create a messy wash in the area around your letter, leaving the space inside the letter white. You can extend the watercolors to the edge of your paper or have it fade out in an organic shape. Let the paint dry **(C)**.

4 Erase any remaining pencil marks.

5 Using gel pens in assorted colors, add doodles and patterns to your watercolor background. Add more washes of watercolor in between the doodles, and use colored pencils to create faint patterns. Be careful not to get any of the doodling and coloring inside the body of the white letter.

6 Use the graphite pencil to draw a drop shadow on the bottom and left sides of your letter.

7 Dip a small paintbrush in water and lightly wash over your pencil marks, creating a slightly transparent shadow.

You're My Favorite Everything

I love taking phrases that I say in real life and turning them into works of art. This piece combines my signature style of script lettering with hand-painted florals, and it makes me happy to look at it. I say this corny little phrase to my husband all the time.

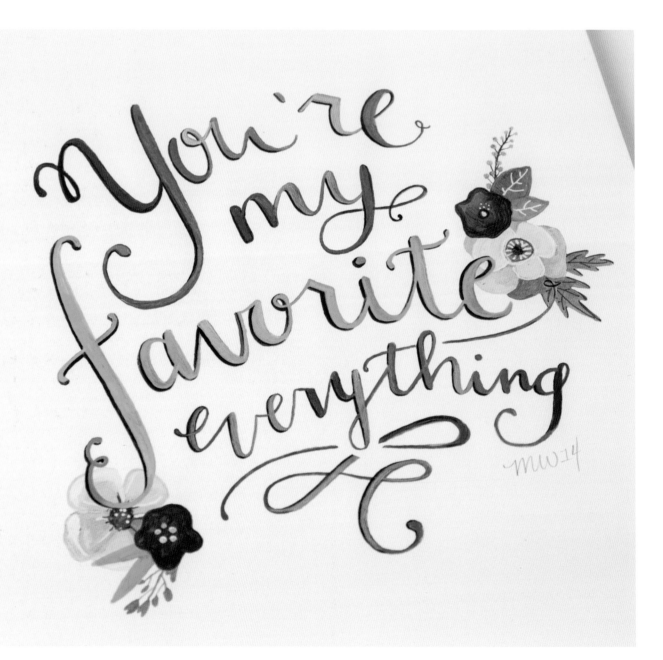

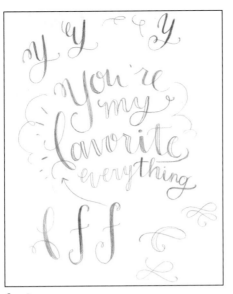

fig. A

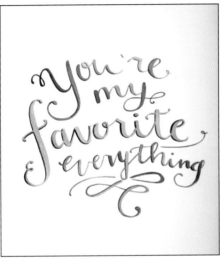

fig. B

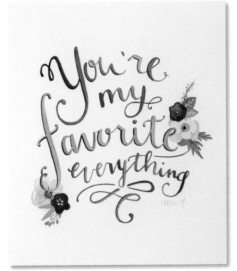

fig. C

What You'll Need

* Mechanical pencil
* White copy paper
* Heavyweight white paper
* Tiny paintbrushes
* Fluid acrylic paints in assorted colors
* Water
* Eraser
* Colored pencils

Method

1 Using the mechanical pencil, sketch thumbnails of the phrase you would like to write on white copy paper. Use the sketches to experiment with different flourishes, sizes, and arrangements of the letters **(A)**.

2 Use the sketch as a reference to very lightly letter the words on white heavyweight paper, again using a mechanical pencil.

3 Use a tiny paintbrush and fluid acrylic paints to start painting one of the words. Water down the paints as you go, to create gradients of value in the letters.

4 Using a darker paint color, paint a very thin drop shadow on the left and bottom sides of the letters. Let the paint dry completely **(B)**.

5 Erase the pencil marks.

6 Paint small flowers and flourishes with the paints. Add details to the flowers with colored pencils **(C)**.

Odd Perspective Lettering

I love playing with perspective and adding depth and dimension to letters. Oftentimes, I'll make up things that don't make sense, just for fun. While some letters have drop shadows underneath, others appear as if they are above. This method can take your lettering to a whole new level of funkiness!

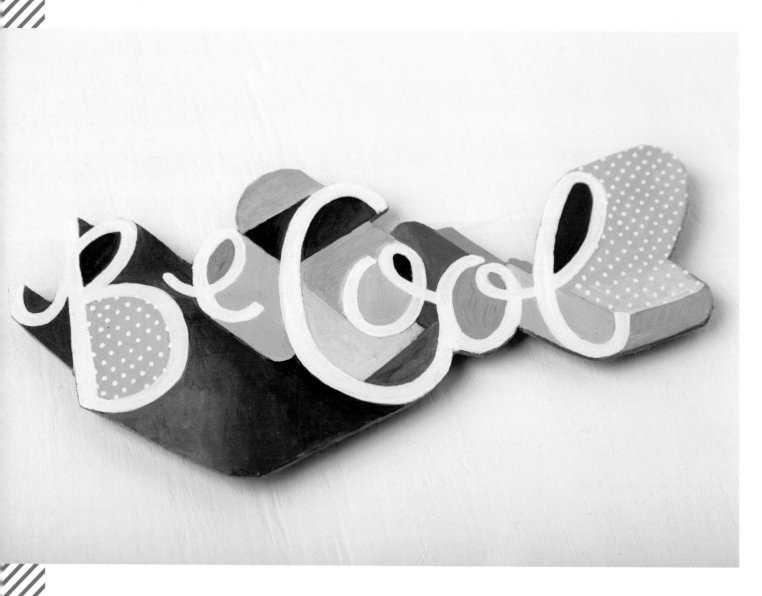

fig. A

fig. B

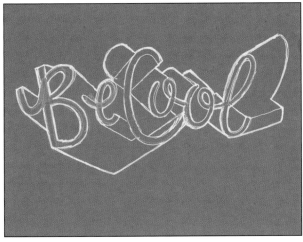

fig. C

What You'll Need

* White copy paper
* Chipboard or cardboard
* Pencil
* White pencil or white gel pen
* Sharp craft knife
* Fluid acrylic paints
* Paintbrushes in assorted sizes
* Black permanent marker

Method

1 Do some sketches of the word or words you want to make on white copy paper. Add dimensional shapes to the letters, varying the direction of the shapes so that some go upward, others downward, some to the left, others to the right **(A, B)**.

2 Use the sketches as a reference to sketch your chosen design onto chipboard with a white pencil or gel pen.

3 Use a sharp craft knife to carefully cut out the word, including all of the dimensional shapes **(C)**.

4 Paint the letters white and the dimensional shapes in assorted colors.

5 Add doodles and outlines with a white gel pen or with more paints.

Sometimes when I'm in a rut, I stretch my creativity by choosing a word or phrase or letter to explore. I draw the same word or letter 30 to 40 times in the span of an hour. It really opens my eyes to all the possibilities. I also vary the materials and surfaces that I use, such as old book pages, graph paper, kraft paper, and dictionary pages. When I do use book pages, I sometimes paint a wash of white acrylic paint and let it dry before I start making the letters on the page. So the next time you are feeling uninspired, gather your supplies and try this exercise. You'll be amazed at how fast an hour goes by and how many variations you can come up with!

This is a great project for the home. It's simple and pretty, and combines the beautiful texture of wood grain with a pop of color. Start by drawing the outline of your selected letter on a piece of unprimed cradled wood panel. Then carefully stain the area around the letter using a small, flat paintbrush. Be aware of what direction the wood grain is headed: the stain will spread in that same direction so apply it very slowly as you get near the outlines of the letter. Once dry, use white acrylic paint and a small paintbrush to fill in the letter. For tiny corners, you can use a white gel pen. Keep the cradled panel plain with just the letter, or add flowers with acrylic paints. Either way, the white paint contrasting with the wood stain creates a bold look!

a b c d e f g h
k l m n o p q
t u v w x y

Diane Henkler

www.inmyownstyle.com

My dad was an engineer and had a lettering book in his desk at home, from his college drafting days, along with some India ink and pens with nibs. I used to love looking through it as a child. I loved trying to copy the lettering styles in the book. I practiced all the time on yellow legal pads and used to make greeting cards to give my family and friends, using many different styles of hand lettering and script. I still have the lettering book. It is tattered and torn, but every time I see it, I smile.

FAVORITE LETTER

I like the letter K most because I like the way you can make curlicues and loops on every stroke.

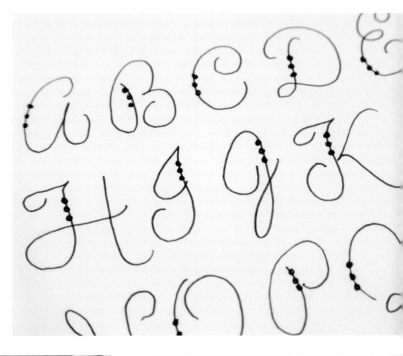

FAVORITE WRITING INSTRUMENT

The Alvin Penstix Technical Markers are my favorite writing instruments. They produce clear, sharp lines that are quick-drying and don't smudge or bleed through the paper. They come in three different widths: fine, medium, and thick. I like the fine one the best because it is great for drawing small details on letters.

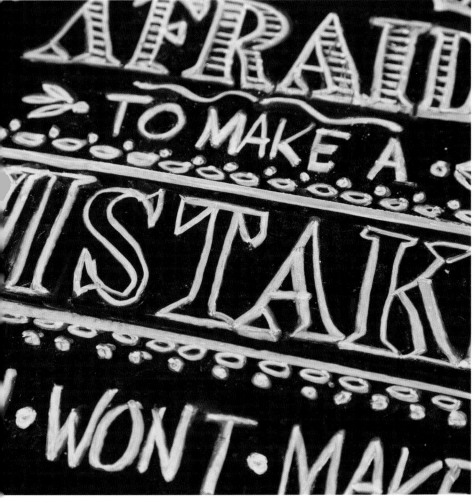

Script Alphabet with Variations

For these alphabets, start by making a basic script letter.

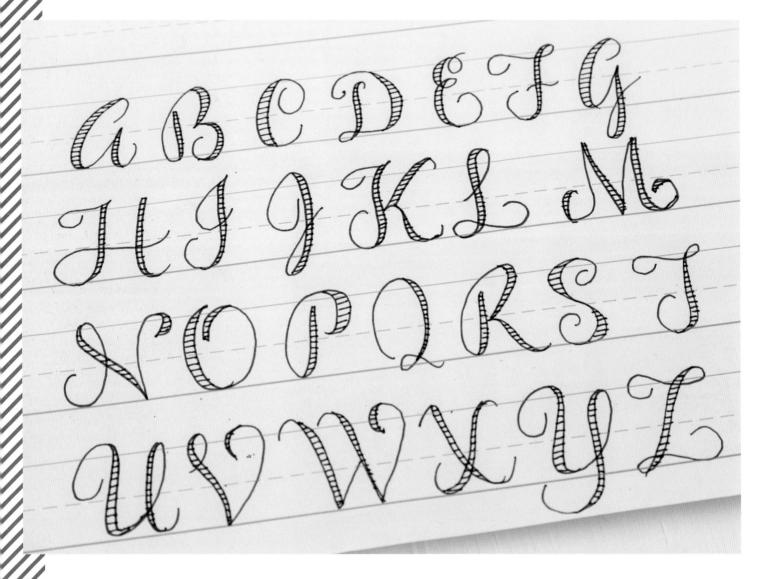

fig. A

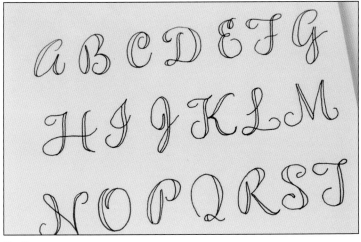

fig. B

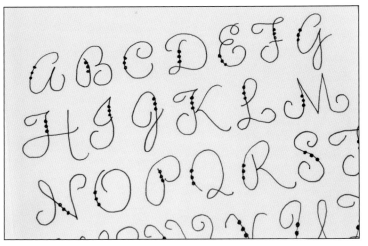

fig. C

What You'll Need

* Black fine-point marker
* Lined lettering paper
* Translucent paper

Method

1 Using a black marker and lined lettering paper, draw a basic script letter alphabet the way you learned in elementary school. Round out the letters and add loops and curlicues to the end and beginning of each stroke **(A)**.

2 Draw a down stroke along one side of each letter. I usually do this on the left side but you can do the right side or even both sides **(A)**.

3 Fill in the open areas created from step 2 with tiny horizontal lines. You can vary this by filling the areas in completely or leaving them empty. Another variation is to add three solid dots to just one stroke in each of the capital letters **(A, B, C)**.

4 Place a sheet of translucent paper on top of the lettered lined paper and trace the letters with the black marker.

If You Are Afraid

The transfer method that I use will help you make a lettered chalkboard that looks great. But remember that lettered chalkboards don't have to be perfect to look good. I've always used water that I dip my chalk into to get it looking very white when it dries. That is my signature. It looks a bit heavier than just using dry chalk but does make the chalk look almost like it is painted on. I have chalkboards in my kitchen and use them outside when entertaining. They make a party or any gathering more festive.

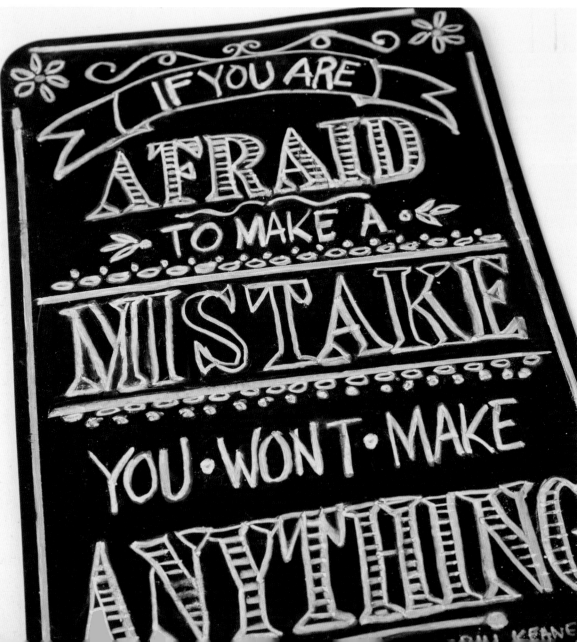

fig. A

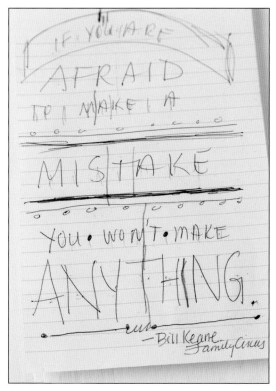

fig. B

What You'll Need

* White chalk
* Chalkboard
* Soft cloth
* Soft lead pencil
* Sketchbook
* Large pieces of white paper, the same size as your chalkboard (you can use large pieces of butcher paper or tape together regular printer paper to make large sheets)
* Clear ruler
* Red fine-point marker
* Soft eraser
* Painter's tape
* Hard lead pencil
* Cup of water
* Fingernail whitening pencil
* Cotton swabs
* Optional: Hairdryer

Method

1 Place a piece of chalk on its side and rub it all over your chalkboard. Wipe off any residual chalk dust with a soft cloth and set it aside. This is a chalkboard seasoning process that allows designs to be drawn without ghosting (the shadow of previous drawings that remains, even after the drawings have been erased) **(A)**.

2 Using a pencil, sketch a preliminary chalkboard design on a piece of paper to help you visualize your design, exact wording, and style of lettering. You will need to find the center of each line of lettering. To do this, count each letter and the spaces between each word in each line **(B)**.

The letter or space that falls in the middle of the total number of letters and spaces is the letter or space that should be centered.

For instance: "Happy New Year" has 12 letters and 2 spaces in between the letters. To fit all of it in one line, you need to plan for 14 characters. Half of 14 is 7, so the seventh character—in this case the letter "N" in the word "New"—is the center of the line. This is the basic way to center. If you have one leading letter that is bolder or bigger than the rest, you may have to account slightly for that.

3 Establish the center point on your chalkboard-sized paper with a ruler and a red marker: first measure and draw a horizontal line halfway down from the top and then a vertical line halfway in from one of the sides. The point where these lines intersect is the center point. This will divide your paper into four quadrants.

4 Using your preliminary sketch and the soft lead pencil, draw your design out on the paper, using the red lines and center point to guide you. Do all of your design work on your paper until you have the design and lettering styles exactly the way you want it. Use a soft eraser to erase and redraw as necessary **(C)**.

5 Once you like your design, place it face down on a flat work surface. Place a piece of chalk on its side and rub the backside of the paper, making sure to cover the entire surface **(D)**.

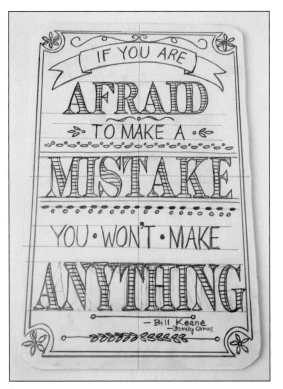

fig. C

fig. D

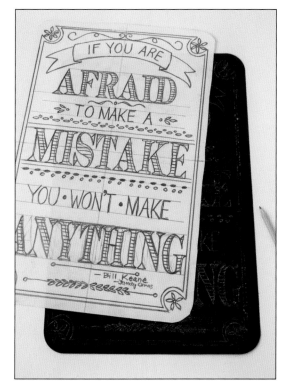

fig. E

fig. F

6. Hold the paper up and shake it to remove some of the chalk. Place the paper onto your chalkboard with the chalked side facing down, making sure that it is centered. Use painter's tape to hold it into place.

7. Use a hard lead pencil to draw over every element on your design. You want to press hard enough so that chalk is transferred to the chalkboard **(E)**.

8. Remove the paper to see the faint chalk lines of your design on the chalkboard.

9. Dip chalk into a cup of water and start drawing over all the lines on the chalkboard. Re-dip the chalk into the water as you keep working so that it remains damp for all the lettering and design elements. To make very fine lines, dip a fingernail whitening pencil in water and use it just like chalk. If you need to rework any areas, dip a cotton swab in water and use it to clean up any smudges and tight areas. If you want to, use a hairdryer to speed up the drying time of the chalk **(F)**.

PRESTO CHANGE-O

The easiest way to do something fancy with letters when you first start out is to just use your basic printing or script and embellish it somehow. Add dots, lines, curlicues, swirls, or a simple doodle of some sort to each letter. Presto change-o! Super fun and easy hand lettering!

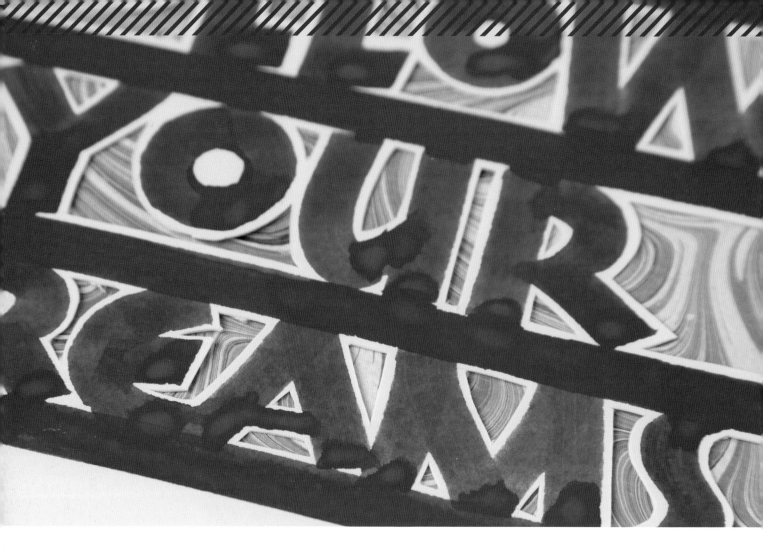

Roann Mathias

www.roanndesigns.com

My mother is a lettering artist who inspired in me an early love of letters. She had an old wooden drafting table where she made signs for my father's store. I loved looking at all her pens and tools and can still remember the smell of the bottled inks. She taught me how to use the large metal nibs that resemble brushes. I got really serious about calligraphy in high school and kept on taking classes through college and beyond. For the past 35 years, I've been a calligrapher and workshop instructor. Along the way, I have acquired skills that complement lettering, including bookbinding, painting, and mixed media.

FAVORITE LETTER

R is my favorite letter, and also my initial. It's a fairly challenging letter to write as a capital, but I like the potential it has for a very nice flourish at the end of it.

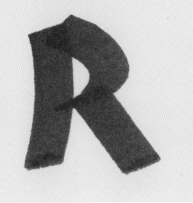

FAVORITE WRITING INSTRUMENT

Without question, my favorite writing instrument is the Parallel pen by Pilot. They are made so the barrels can be filled with almost any kind of ink or writing fluid. The corners of the nibs can be used to draw fine lines. They write continuously without having to reload like dip pens, so that a good writing rhythm can be kept up. There is no set-up time, so you can just whip one out to address an envelope or write a short note.

Masked Dream

Masking fluid is like magic fluid. Once you understand how to use it, a whole new universe will open up for you and your lettering projects.

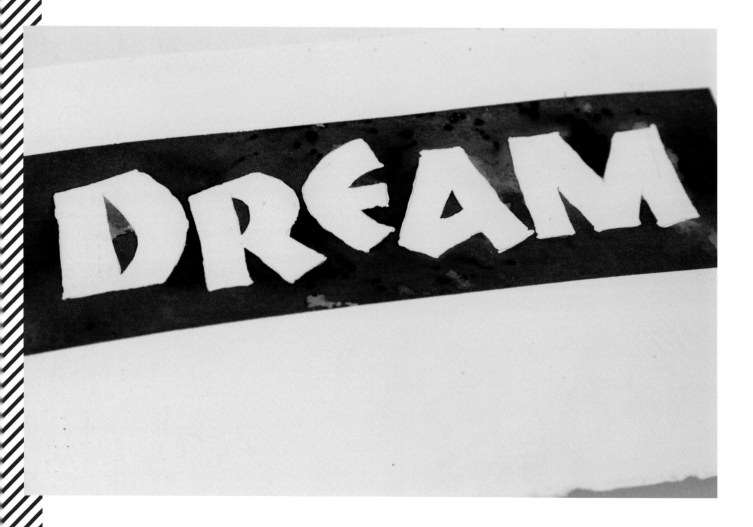

fig. A

fig. B

fig. C

What You'll Need

* White heavyweight paper
* Mechanical pencil with eraser
* Masking fluid
* Small, inexpensive paintbrush
* Masking tape
* Walnut ink crystals
* Small bowl with water
* Large 1-inch (2.5 cm) paintbrush
* Spray mist bottle with water
* Kneaded eraser (optional)

Method

1 On heavyweight paper, use a mechanical pencil to lightly draw a word in the Neuland alphabet style (page 75) **(A)**.

2 Use a small paintbrush to fill in the letters with masking fluid. After use, the brush will probably be ruined, which is why you should use an inexpensive one. Let the fluid dry **(B)**.

3 For a crisp border/frame, tape off a rectangular area that encompasses the word with strips of masking tape.

4 Follow manufacturer's instructions to mix walnut ink crystals in a small bowl with water to activate the crystals into walnut ink.

5 Use the larger paintbrush to apply walnut ink in the area within the masking taped area, including all of the letters' spaces. While the ink is still wet, sprinkle in a few grains of the crystals in random areas. Mist the grains with water to help them have a splintered, web-like effect. Let the ink dry **(C)**.

6 Rub off the masking fluid with your fingers or a kneaded eraser.

7 Carefully erase any residual pencil marks.

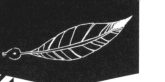

Follow Your Dreams

With the help of a sharp craft knife, this project helps us see what *is* there (positive space), by taking away what's already *not* there (negative space).

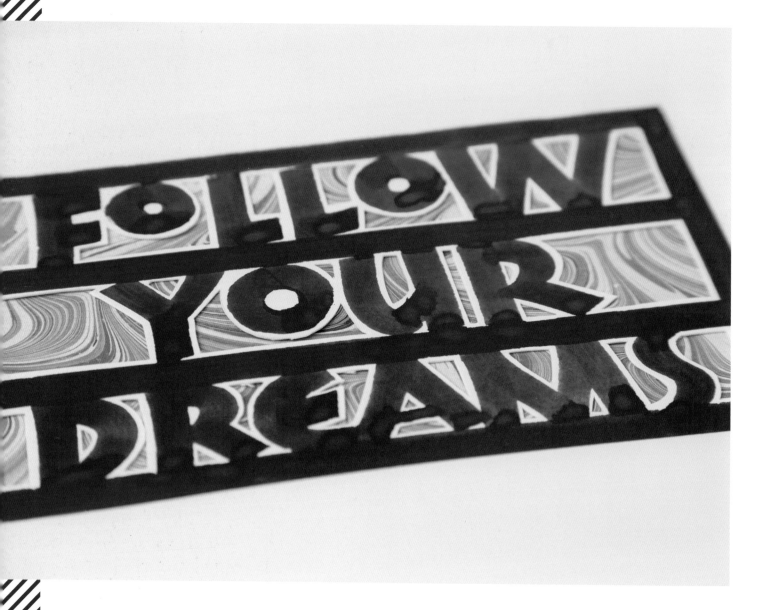

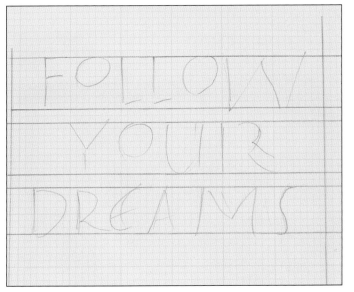

fig. A

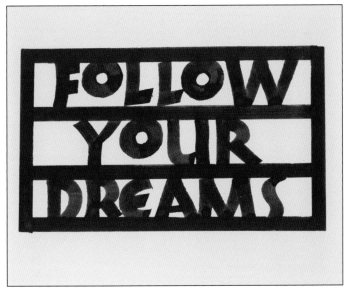

fig. B

What You'll Need

* Grid paper
* Mechanical pencil
* White heavyweight paper
* Parallel pen (or a calligraphy pen with a wide nib)
* Ruler
* Sharp craft knife with fresh blades
* 1 piece of decorative paper, slightly smaller than the white heavyweight paper

Method

1 Use grid paper and mechanical pencil to make a light sketch to plan out the design of your words. The letters in this project were approximately 1 inch (2.5 cm) tall, with approximately ¼ inch (6 mm) between each row of words **(A)**.

2 Use a Parallel pen or calligraphy pen and ink to write out the words onto heavyweight paper. Make sure you leave approximately ¼ inch (6 mm) in between each row of words. Don't worry if you feel the words aren't precisely aligned. The lines you make in the next step will unify everything.

3 Use the pencil and ruler to make vertical lines on the left and right sides to mark the sides of the frame for the words.

4 With the pencil marks from step 3 as guides, use a ruler and Parallel pen to draw thick lines between the rows of words, as well as lines above and below to complete the frame **(B)**.

Allow these lines to be thick enough to have the tops and bottoms of the letters touching the lines, and also be mindful to carefully square off the corners.

5 Erase any residual pencil marks. Use a sharp craft knife with a fresh blade to carefully cut around the letters, leaving about $\frac{1}{16}$ inch (2 mm) of white paper around the letters **(C)**.

6 Attach a piece of decorative paper on the backside of the white paper **(D).**

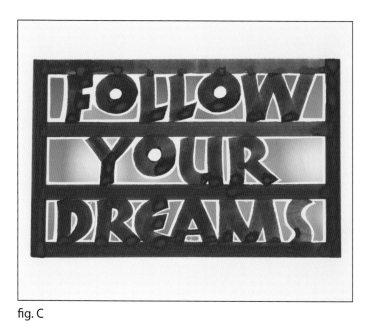

fig. C

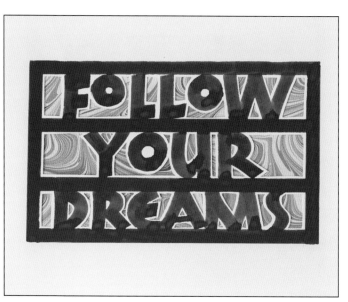

fig. D

ABCDEF
GHIJKL
MNOPQ
RSTUV
WXYZ

The Neuland alphabet was designed in 1923 by Rudolph Koch. It is a popular style among calligraphers because it is straightforward, with lots of potential for variations. You can use a pen with a thick nib to make the solid, dense strokes, or you can use a highlighter or marker with a thick nib. Once you master that, you can practice making an outlined version. Both variations are shown here.

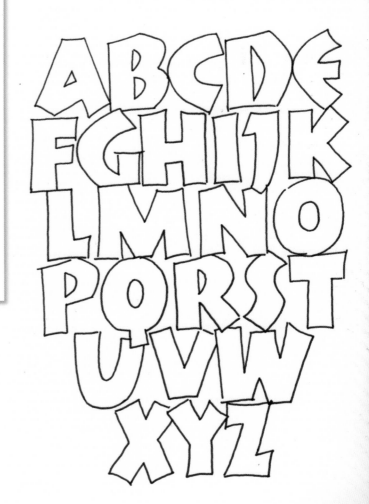

Magic

This project has all the charm of watercolors but because you use Inktense pencils instead of actual paints, the process is a lot easier, and the results are wonderful.

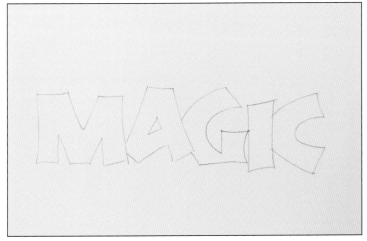

fig. A

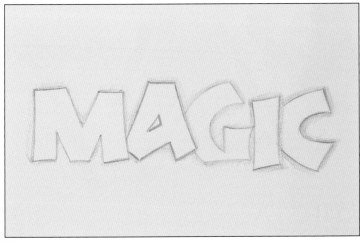

fig. B

What You'll Need

* Mechanical pencil
* White heavyweight paper
* Derwent Inktense pencils in assorted colors
* Cup of water
* Small paintbrush

Method

1 Use a mechanical pencil to lightly sketch your word onto heavyweight paper **(A).**

2 Use an Inktense pencil to outline the first letter. Make the firmest marks on the actual outline of the letterform and gradually lighten your touch as you progress away from the letterform. Repeat for all other letters in different colors **(B).**

3 Use a small wet paintbrush to blend the color of the first letter. The outline will look the darkest and the area around the letter will look lighter. Repeat with all other letters, rinsing out the brush in between each color.

IDEA

For a different effect, outline the letters with an inktense pencil and gradually lighten your touch as you progress inside the letterforms. Use a wet paintbrush to blend the colors inside the letterforms.

Doodled Fun

Because the Neuland letterforms are so chunky, they are ideal for filling with doodles. It's easy and fun!

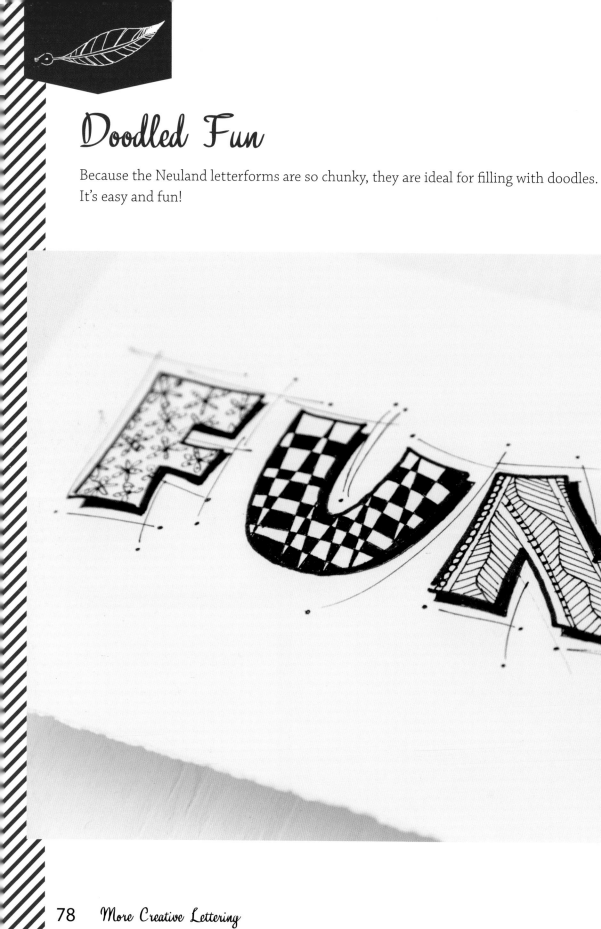

fig. A

fig. B

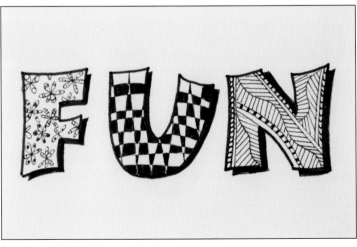

fig. C

What You'll Need

* White heavyweight paper
* Black permanent markers in assorted nib widths

Method

1 Using a black marker, draw the letters of the word onto the white paper **(A).**

2 Add a drop shadow to the right and lower sides of the letters with the marker **(B).**

3 Add assorted doodle designs within the body of each letter with markers in varying nib widths **(C).**

4 Use an extra-fine-tip marker to make lines and dots around the outer parts of the letters.

TRACING HELPS

Do you remember how much fun it was to trace things as a child? Guess what? It's okay to trace as an adult! Tracing helps to show your hand how a letter is supposed to be made. Tracing develops muscle memory.
A good way to practice is to alternate tracing with freehand lettering of the same alphabet. Keep switching back and forth to see how you are progressing and to build confidence about the letter shapes.

Kerri Winterstein

www.yourwishcake.com

I've always loved lettering. As a young girl I remember poring over lettering books I would get from the book orders at school, carefully tracing over the loops and curls and intricate details of the letters on each page. My mom always encouraged me to have fun with my handwriting and gave me every opportunity to insert a bit of artwork into anything I was studying. Although beautiful typography will always have a special place in my heart, there is just something about unique, one-of-a-kind handwriting that I find so charming.

FAVORITE LETTER

The letters K and W are my initials and they are my favorite. My mom told me that one of the reasons she decided to spell my name with a K and not a C is because the letter K is much more fun to write. I definitely agree, and I love that I inherited my appreciation of handwriting from her.

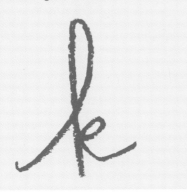

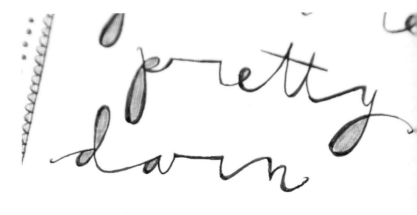

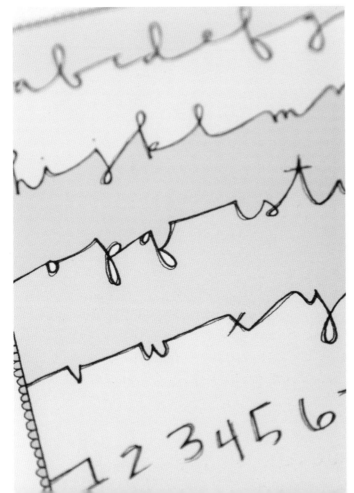

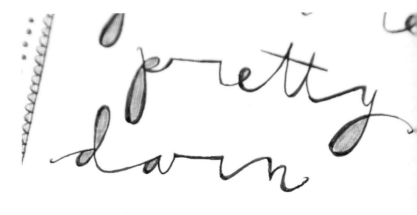

FAVORITE WRITING INSTRUMENT

Basic black pens are my happy place. Whether I'm using an ultra fine point Sharpie or my go-to extra fine point ink pen, I love the consistent amount of pigment this style of nib provides, and the smoothness of the line they create. Hands down, I always like my handwriting better when using a black ink pen. Recently, I've rediscovered some beloved writing instruments from my childhood that I'd forgotten about: colored pencils and fine-point markers. Thanks to my young daughter, I get to dabble with these things throughout the day as I encourage her own creativity!

Loopy Cursive Alphabet

This loopy cursive is something I find myself using all the time. While the classic cursive of my childhood was meant to be perfectly neat and uniformly sized, I have found so much freedom in this more carefree style. No letter needs to be the same twice. You can make the loops extra-high, you can add an extra-long line for one specific letter, you can make them close together or far apart. Using one variation consistently is how I've made this alphabet my own. For example, I always extend the line of the letter R more than the other letters. You can easily find a variation that you want to exaggerate and be consistent with what fits your style. The methods here will teach you how to use Photoshop (or Photoshop Elements) to make a digitally colorized piece using this alphabet. It's easier than you might think!

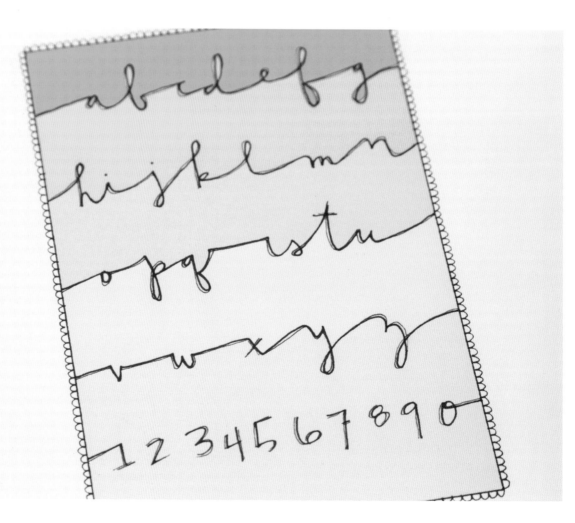

What You'll Need

* White copy paper
* Paper cutter
* Black fine-point permanent marker, 0.5 mm
* Black extra-fine-point permanent marker, 0.1 mm
* Scanner
* Computer with Photoshop (or Photoshop Elements)
* White heavyweight cardstock
* Color printer

Method

1 Cut one sheet of copy paper in half to make two pieces that measure 5½ x 8½ inches (14 x 21.6 cm).

2 On one of the paper halves, use a fine-point marker to make a rectangle on the page, leaving about 1 inch (2.5 cm) of white space on all sides. This rectangle doesn't have to be perfect. A little bit of wonkiness adds character. Add small half-circles around the rectangle border. With the rectangle placed vertically, draw the middle line of letters: o-p-q-r-s-t-u. Draw the line above, then the line below. Finish by drawing the line farthest above and then the numbers farthest below. Working in this order will help you better gauge how to space all the lines of lettering.

3 Use the extra-fine-point marker to go back over the letters, this time adding lines here and there, slightly away from the original letters. The point is to give each letter a more handwritten, imperfect quality.

4 Once you're happy with your piece, scan it into your computer and then open it in Photoshop (or Photoshop Elements) and do the following:

 * Crop as needed.
 * Adjust the contrast as needed. If you feel the black lines aren't bold enough, use the Paint Bucket tool to carefully fill each line with black.
 * Use the Paint Bucket tool to fill in each section of the backgrounds with white. Be sure to fill in the

main loops of the letters, numbers, and border, but don't worry about filling in all the tiny loops and lines you added with the extra-fine marker. Note: If you think you will be reusing this image again in the future (perhaps with different colors), now would be a good time to save the image to your computer. That way, you will be able to start with a plain black and white image the next time around.

 * Select the colors you would like to use for each section of the artwork, and fill in the image using the Paint Bucket tool.

5 Add cardstock to your printer and make sure your printer settings are set to the correct size and paper type and quality. Print your work.

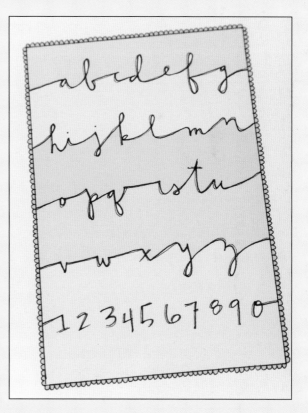

You Are Awesome

This piece showcases a variation of my usual cursive, with a few extra curves and a more calligraphic style. I've become fond of the square format, and love how a simple pattern of doodles frames the lettering, taking this piece from a simple note to a piece of art.

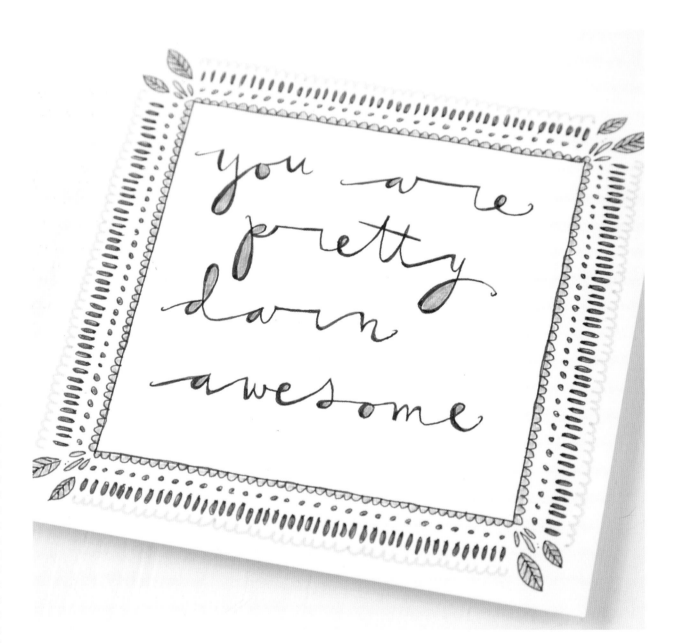

What You'll Need

* White heavyweight cardstock, 5 inches (12.7 cm) square
* Black fine-point permanent marker, 0.3 mm
* Yellow, red, green, and cream colored markers

Method

1 With the black marker, draw a square on the cardstock, keeping a border that is approximately ¾ inches (1.9 cm) on all sides.

2 Draw each word in cursive within the square, without worrying too much about keeping the letters perfectly balanced or centered.

3 Use the same marker to go back over each letter, making certain lines and loops slightly thicker while keeping some thin. Add a small curl to the beginning and ending lines of each word.

4 Add small half circles around the square. Continue creating a doodled border around the square by adding rows of tiny circles and ovals. At each corner, add three teardrop shapes and two leaves in varying sizes.

5 Use the colored markers to add color to parts of the letters and the border.

Be Brave Wall Art

Finding ways to showcase my lettering style away from paper is a challenge, but I've found that embroidery is one way to do just that. Because this piece uses only one basic, easy-to-learn stitch, it's perfect for even those who consider themselves to be a novice when it comes to embroidery. A simple pattern and bold letters make this eye-catching design the perfect mix of modern and classic. The end result is a beautiful piece of lettered and embroidered hoop art that can be hung on the wall.

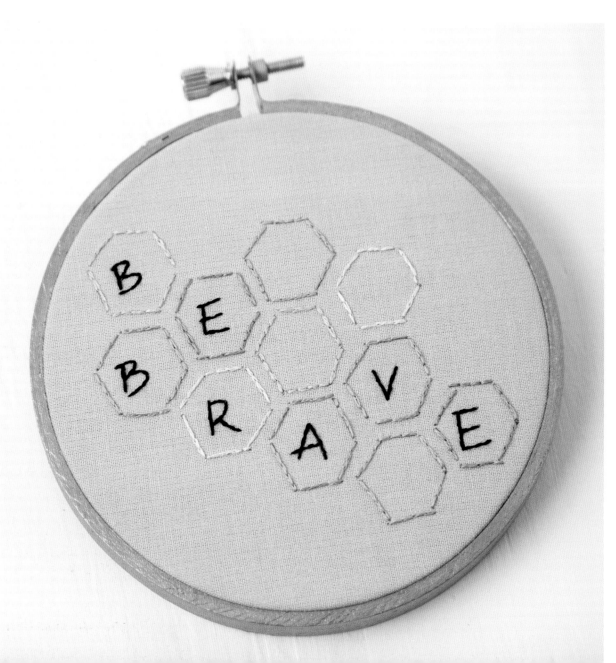

What You'll Need

* White copy paper
* Be Brave template, shown here
* Masking tape
* Well-lit window (or light box)
* 2 pieces of light-colored cotton fabric, each 6½ x 7½ inches (16.5 x 19 cm)
* Black extra-fine-point permanent marker, size 0.1 mm
* Wooden embroidery hoop, 4 inches (10.2 cm) diameter
* Hand-sewing needle
* 6-strand embroidery floss in black, Desert Sand, Very Dark Straw, Medium Baby Green, Light Orange Spice, and Very Light Pearl Gray*
* Small paintbrush
* Gold enamel paint
* Hot glue gun and glue sticks

The artist used DMC embroidery floss in colors 310, 3064, 3852, 966, 722, and 762.

Method

1 Make a copy of the template shown here and enlarge it 25 percent. Tape it onto a well-lit window. Place one piece of the fabric on top of the paper, tape it to the paper, and trace the design with the black marker. Remove the fabric from the window.

2 Place the traced fabric on top of the other piece of fabric and then place both layers inside the embroidery hoop, with the traced fabric on top and facing up.

3 With two strands of the black embroidery floss, use a backstitch to embroider the letters. Continuing with a backstitch, use two strands each of the

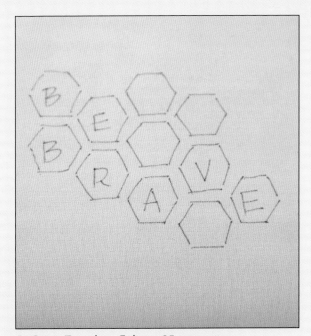

Be Brave Template. Enlarge 25 percent

remaining colors of floss to embroider the hexagons. Knot the end of each color when you are done stitching and trim with scissors. Remove the fabric from the hoop and set aside.

4 Using a small paintbrush, paint the outside of the hoop with two layers of gold paint. Let dry.

5 Place the embroidery back into the hoop with the screw centered at the top, and secure the screw. Trim off excess fabric, leaving about ½ inch (1.3 cm) all around.

6 Using a hot glue gun, carefully add glue to the inside of the hoop and fold the extra fabric around to the back to secure. *Note:* Take care to not get the glue too close to the stretched fabric in the center of the loop, otherwise the glue will show through the finished embroidery. Just a little bit of glue along the edge is plenty to ensure the fabric stays folded down on the underside of the hoop.

Paper Packages

Sending pretty packages is something that is very near and dear to my heart. I always try to add a bit of personality to anything I'm sending in the mail, and bold lettering paired with a handful of doodles is usually the way to go. With a few simple, inexpensive materials and a little bit of effort, you can dress up boxes of any shape or size!

fig. A

fig. B

fig. C

What You'll Need

* Postal wrapping paper (or kraft paper) large enough to cover the box you are sending
* Scissors
* Colored pencils, black and white
* Clear packing tape

Method

1 Cut a piece of paper large enough to cover the box you are sending.

2 Check to see where the address needs to be written by folding the paper over the box or package to be wrapped. Note where the front of the package will be.

3 Draw the address on the paper by using black and white colored pencils to make a combination of cursive letters, capital block letters, and lowercase letters. Add doodles and embellishments **(A, B, C)**.

4 Wrap package and secure the paper with packing tape.

Simple projects like these have really helped me discover and perfect my own lettering style. I've always been a collector of quotes and when I find one that particularly speaks to me, I am sure to write it down. This piece was made on a square piece of cardstock. Using a fine-point black marker, I lettered the "you are" with the flourishes first and then lettered the rest of the quote working from the center out. Then I doodled the laurel elements and added color with assorted colored markers.

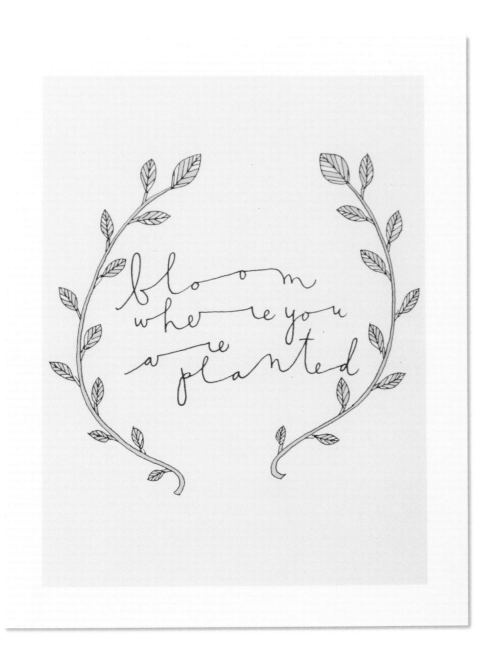

When I first started creating lettered projects and illustrations, I wanted to find a way to turn my favorites into digital prints, but I was sure it would be entirely too time consuming. Once I figured out how simple it is to digitize my work (as explained in my Loopy Cursive Alphabet project, page 82), it opened up a new world for me! Adding color digitally retains the handwritten quality of the lettering while also making the entire image so dynamic. It's also quite nice to have the luxury of changing the colors around a few times without having to start an entire project from scratch. The hexadecimal color values I chose for this piece are: Background (#DCF2EF), Stem (#A5CBA6), and Leaves (#A5CBA6, #D9F1B5, and #EBF5DA).

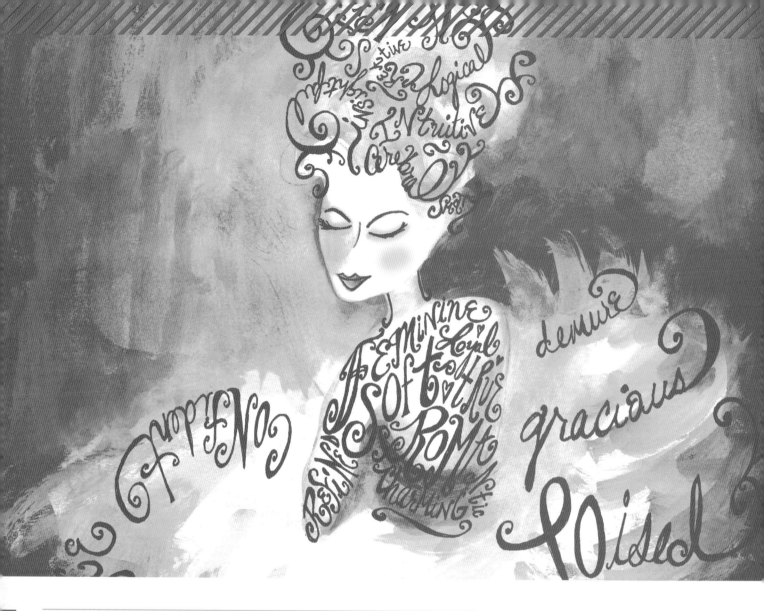

Kristine Lombardi

www.kristinelombardi.com

I won a contest in middle school and got to paint a store window in town. That was probably my earliest attempt at decorative lettering. I am now a commercial illustrator who is inspired by all things vintage. In terms of lettering and illustrating, I love to experiment with different mediums. Experimentation is how your hand-lettering style will emerge once you discover what is most fun to you.

FAVORITE LETTER

I love the letter A, as it's equally fun to ink in uppercase and lowercase.

FAVORITE WRITING INSTRUMENT

The extra-fine Pilot Precise V5 Rolling Ball pen is my favorite writing instrument. I also love using brushes and chopsticks with India ink.

Lettered Silhouettes

I love to letter iconic shapes. The silhouette of a bridal gown is a beautiful one for this method, as it is a shape with timeless appeal. Once you get the hang of it, you'll see that practically any silhouette can work with this method, including a dancer, baby carriage, and more!

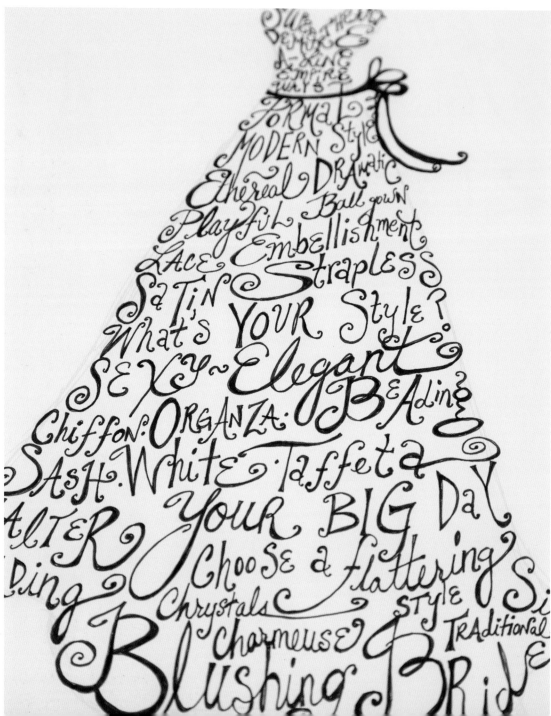

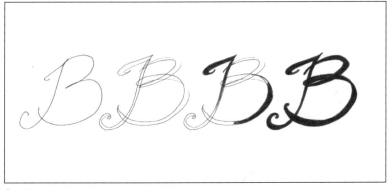

fig. A

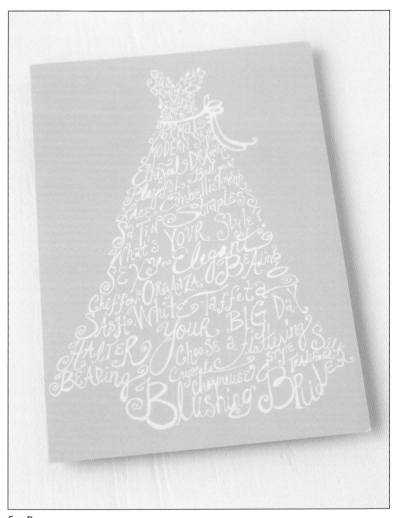

fig. B

What You'll Need

* Mechanical pencil, size 0.5 mm
* Eraser
* Black fine-point marker
* Scanner and computer with Photoshop (optional)
* Printer

Method

1. Using a pencil, lightly sketch a bridal gown silhouette with very simplified lines.

2. Make assorted bride-related words within the silhouette using the pencil.

3. Trace over the words with a black fine-point marker. Make additional closed counter strokes on every part of the letter and then fill those closed spaces with the black marker **(A)**.

4. Carefully erase the pencil marks of the wedding gown.

5. You can stop there or you can scan the work into your computer and then use Photoshop to clean up any parts of the work as needed, and then add coloring to the background and letters as desired. Make prints of the final work on your computer or get it professionally printed **(B)**.

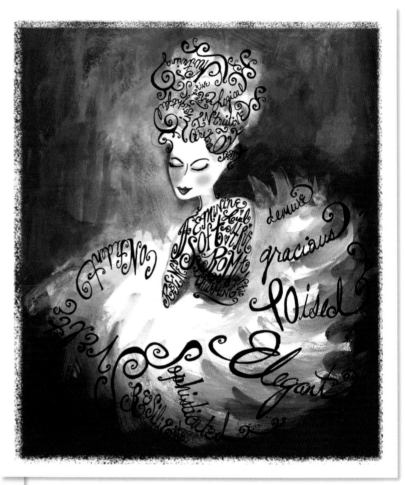

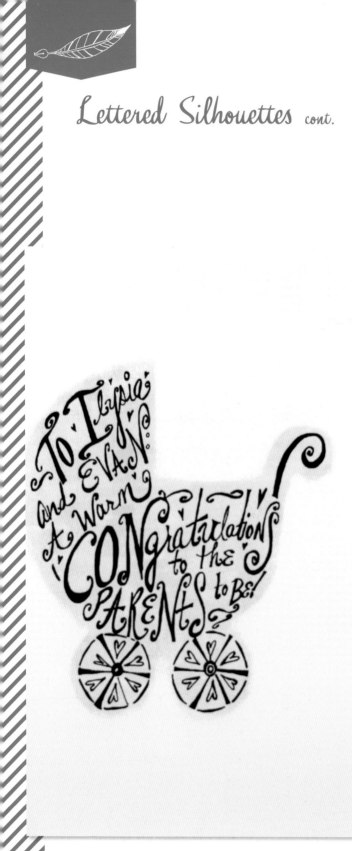

VARIATION

These same methods were used to create the baby carriage and the woman. Note that when parts of the silhouette are empty because a word does not stretch all the way, you can add small flourishes or doodles, like the wheels and handle on the baby carriage to fill the space.

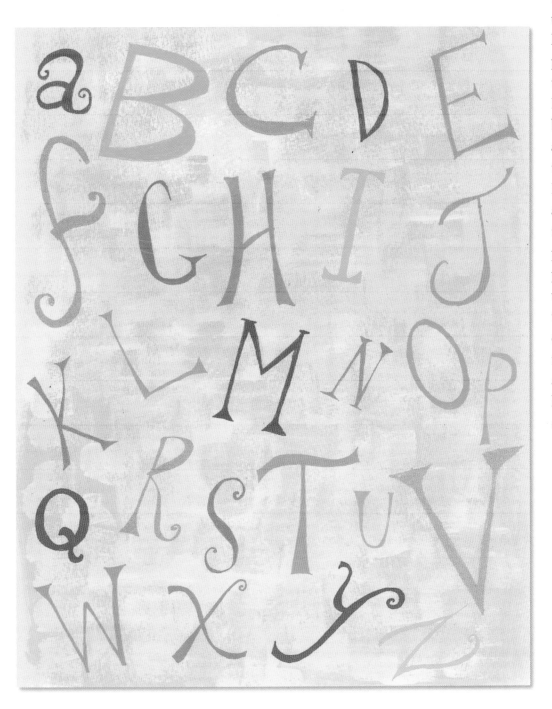

This alphabet is made with a combination of uppercase and lowercase letters. I made this poster by first sketching the letters with a pen. Next I painted a textural background in Photoshop and then scanned each of the letters into Photoshop. I adjusted the letters, added colors to them, and then composed the entire piece using the layers palette. An alternative way to do this would be to paint a wash of color onto watercolor paper, then pencil in the letters, and ink over the penciled letters with assorted colored markers.

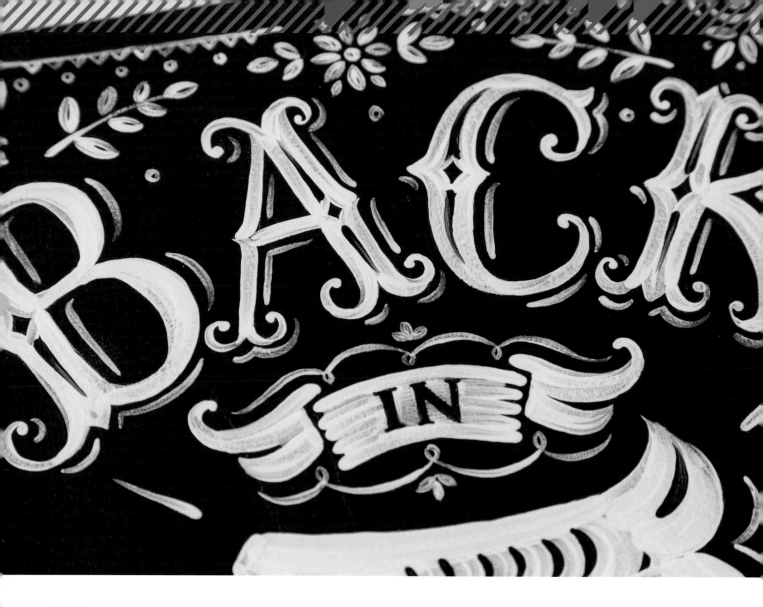

Alexandra Snowdon

www.snowdondesignandcraft.com

My grandpa was the person to first introduce me to hand lettering. He was a graphic designer who used brushes and paints to produce posters by hand. I used to stay with him and my grandma during school holidays and spent many happy hours in his shed, picking up lettering tips as I watched him work. When I got home, I used to doodle and try to draw fancy letters with little pictures. Some of them came out okay, others not so good, but I remember just really enjoying the process and having fun experimenting.

FAVORITE LETTER

The uppercase R is my favorite letter. It is difficult to draw but so rewarding to get right. I love the way it can be extended to curl around the other letters or swept right across under the whole word.

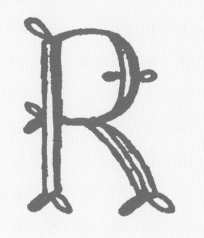

FAVORITE WRITING INSTRUMENT

My favorite writing instrument is the Pentel P205 mechanical pencil. I've had it since the first day of my first job as a graphic designer. I've used it so much over the years it almost feels like an extra finger on my right hand.

Fairground Alphabet

The resurgence of the western/fairground style of lettering is the thing that initially inspired me to start experimenting with hand lettering. I love this alphabet because there are so many variations that can be derived from it, such as adding leaves and flowers and fine or chunky drop shadows.

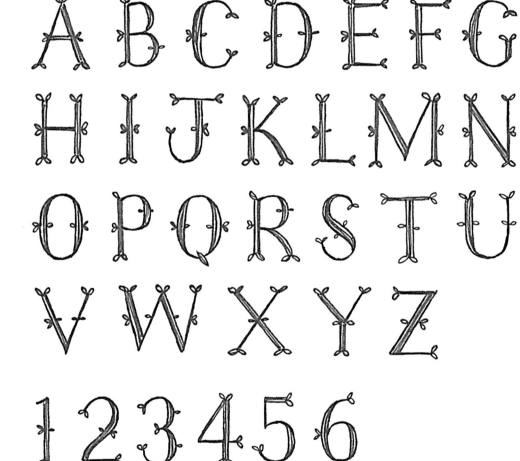

fig. A

fig. B

fig. C

OPTIONAL APPROACH

If the pencil drawing is messy with lots of stray marks on it, you can trace the letters off using a fresh piece of bleed-proof marker paper. Place the paper over the pencil drawing and then place both sheets on a light box, securing them with masking tape. Trace and ink in the design, using the pigment pen, followed by white opaque ink to make any corrections.

What You'll Need

* Mechanical pencil, .05 mm
* White heavyweight paper
* Black fine-point pigment pen
* Firm putty eraser
* Superfine paintbrush
* White opaque ink
* Optional:
 - Bleed-proof marker paper
 - Light box
 - Masking tape

Method

1 Using a mechanical pencil, sketch out the basic letter shapes onto a piece of white heavyweight paper, adding emphasis to the thicker areas of the letters **(A)**.

2 Draw small leaf-shaped decorative elements **(B)**.

3 Using a black pigment pen, ink over the pencil sketches. Take care not to overwork it, and keep the lines loose and sketchy, leaving some white "open" bits to emphasize the hand-drawn qualities of the work **(C)**.

4 When the ink is completely dry, clean up any visible pencil lines with a firm putty eraser. *Note:* Firm putty erasers are gentler and easier to use than regular erasers and are less likely to crease the paper.

5 If there are any inked-in bits that need correcting, block them out using a superfine paintbrush and white opaque ink.

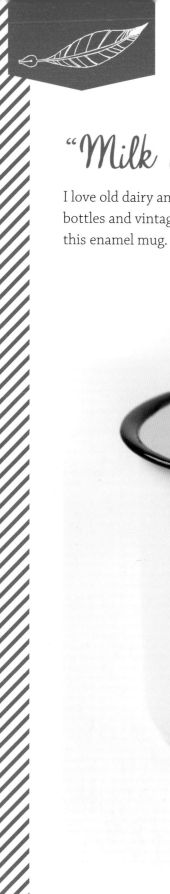

"Milk and Two Sugars" Mug

I love old dairy and grocery store graphics, the kind you find on antique milk bottles and vintage ice cream signs. I used enamel paint for the lettered design on this enamel mug.

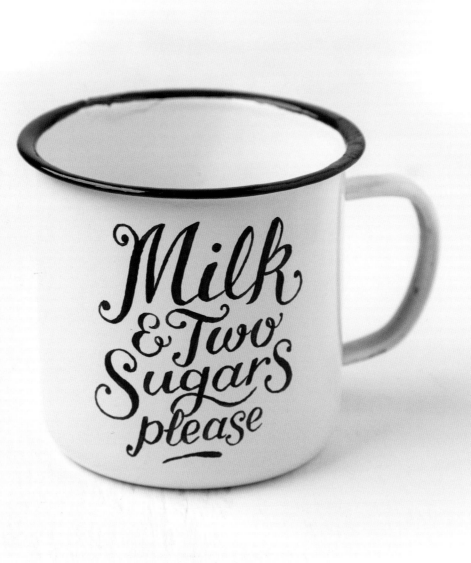

What You'll Need

* Mechanical pencil
* Plain white copy paper
* Optional:
 - Scanner
 - Computer with Photoshop
 - Printer
* Tracedown wax-free paper
* Tape
* White enamel mug
* Ballpoint pen
* Books
* Dark blue enamel paint
* Small paintbrush

Method

1 Sketch the words with a mechanical pencil on paper. Extend parts of the letters to form decorative swirls and sweeping lines that link together or curl around other words. Make some letters larger and extend some ascenders and descenders to fill spaces.

2 *Optional:* Once the design is complete, scan it and use Photoshop to size it to fit the space on the mug. Print out the design and trim it to fit the mug.

3 Trim a piece of the wax-free tracedown paper to be the same size as the design.

4 Tape the tracedown paper onto the mug where you want the design to be painted. Tape the trimmed design on top of the tracedown paper.

5 Using a ballpoint pen, trace around the outlines of the design and then remove both papers. You will see a light transfer of the design on the mug.

6 Place the mug on its side and then place a pile of books slightly higher than the mug right bellow it. The books will be a place to rest your wrist and keep it steady during the painting process.

7 Open your enamel paint and give it a good stir. Don't put too much on your brush because it drips very easily and a little goes a long way. Paint the design with the enamel paint and paintbrush. You won't get brushstroke textures working at this small scale so go back and add extra thickness and detail to your letters if needed, without overworking it.

8 Leave the mug to dry on its side for a few hours. Do not be tempted to blast the paint dry with a hair dryer; that will make the paint go bubbly and create a horrible smell. When the paint is dry, take a damp sponge or soft cloth and gently wipe away any remaining signs of the tracedown outline.

"Back in 5" Chalkboard Sign

I thought this sign would be a fun way to let my customers know I'd be back soon when I needed to pop out for a coffee break! This kind of vintage, folksy lettering really appeals to me, especially when it's hand-painted, because you can see the brush strokes and little quirks and imperfections. It reminds me of fairgrounds, the British seaside, canal boats, and old gypsy caravans.

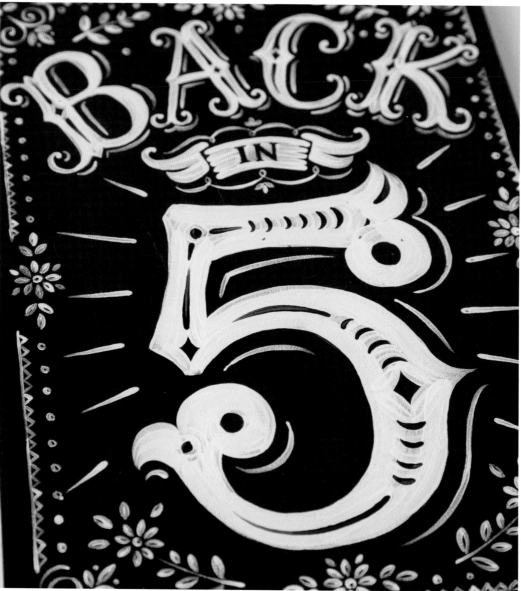

fig. A

fig. B

What You'll Need

* Foam roller
* MDF board, 8 x 11 inches (20.3 x 27.9 cm)*
* Chalkboard paint: nearly black and bright white
* Mechanical pencil, .05 mm
* Sketchbook
* White erasable charcoal pencil
* Chalk paint
* Watercolor paintbrushes, sizes 1, 5, and 6
* Firm putty eraser
* Transparent sealer (optional)

MDF stands for medium-density fiberboard, also known as particle board, laminate, and formica. Plywood can also be used, which is slightly more expensive than MDF.

Method

1 Using a foam roller, paint a sheet of MDF board with two coats of nearly black chalkboard paint, allowing the paint to dry between coats.

2 Gather together image references for the style of lettering and hand-painted design that inspires you.

3 Use a mechanical pencil to sketch the composition of the sign in a sketchbook, emphasizing thick and thin letter stems, and adding decorative flourishes. Think about what parts of the sign and which words need the most emphasis. Try slanting words at different angles or on a curve, and experiment with large and small letters and words.

4 Sketch your finished design very lightly onto the painted MDF board using a white erasable charcoal pencil. *Note:* Do not use a graphite pencil because the remaining marks will be difficult to erase **(A, B)**.

5 Load the largest paintbrush with a good amount of bright white chalkboard paint and apply to the parts

of the design, usually to the words, that need the most emphasis **(C)**. Next, use the smaller paintbrushes to paint decorative elements and borders using watered-down chalkboard paint. A mixture of 1 part water and 1 part paint works well but you can adjust the ratio to get the results that you want. This process will make the most important areas stand out while ensuring a balanced design with maximum legibility.

6 Once the paint is thoroughly dry, use a firm putty eraser to get rid of any remaining signs of the white pencil outline **(D)**.

7 *Optional:* If the chalkboard is going to be exposed to water or inclement weather, then apply a couple of coats of transparent sealer with a foam roller.

TIPS

- If you don't feel confident about drawing your design straight onto the chalkboard, draw it on paper first and then rub chalk on the backside of the sketch. Then place the paper with the chalk-side down onto the chalkboard. Retrace the sketched design with a pencil. This will result in a light ghost transfer of the design that you can use to guide your painting process.
- You could also buy a readymade chalkboard if you don't want to paint one up yourself.

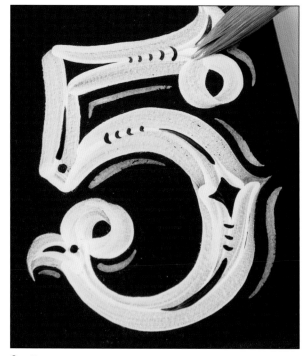

fig. C

fig. D

After finding a lovely old piece of wood in our backyard, I felt inspired to create an old-style, hand-painted shop sign. I used the same methods as described for the "Back in 5" Chalkboard Sign (page 104) to paint the letters. The only thing I didn't do was to paint the wood with a dark chalkboard paint. Instead, I left it in its natural state.

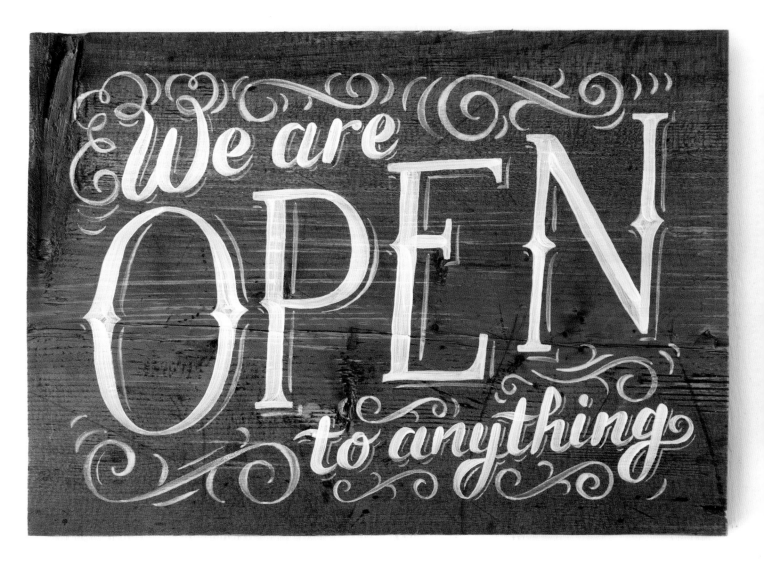

"yay, it's here!" stamp

Any lettered design can become a custom rubber stamp! The important thing about rubber stamps with lettering is that you need to create a mirror image of your design before it is transferred and carved into rubber, otherwise it will stamp the words the wrong way around! The easiest way to do this is to scan your design as a grayscale image, open it up in Photoshop, and flip it horizontally. You can then also scale it up or down to the size you want. Print out the reversed image and trim around the edges. Follow the basic steps of rubber carving (see Rubber Carving Basics, page 109) and carve your design into a rubber stamp.

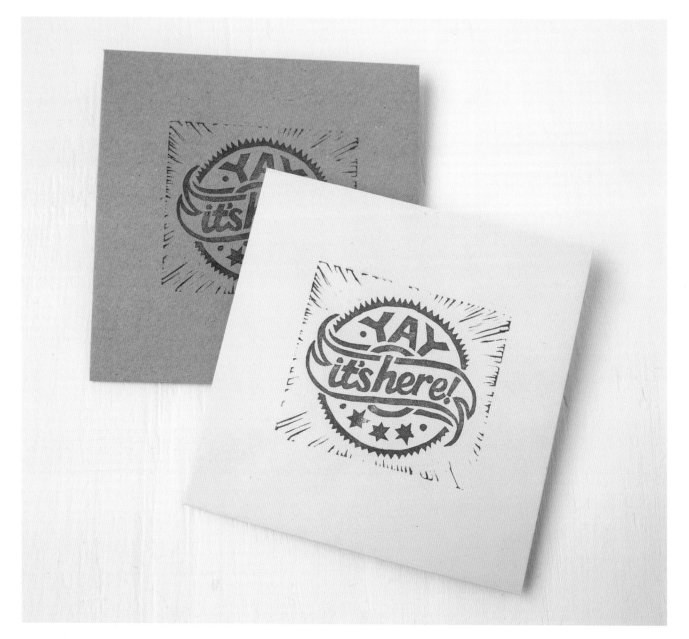

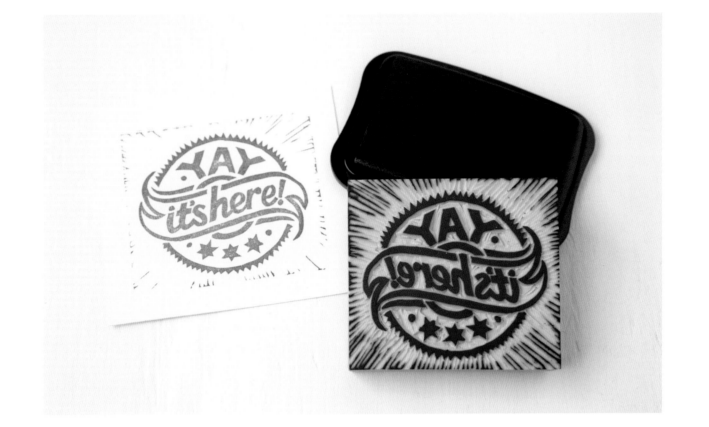

RUBBER CARVING BASICS

Once you've prepared the image you'd like to turn into a rubber stamp using Photoshop, trace the image onto translucent paper. Turn the paper over, lay it on a pink eraser or carving block, and rub the image onto the eraser using the side of a pencil **(A)**. With a linoleum cutter or sharp craft knife, begin carving your eraser or block using the burnished image as a guide **(B)**. Start by carving the major outlines, and then carve the smaller details. The raised portion of the image is what's going to show up as a stamp, so make sure you pay attention to which parts of the image you're going to carve away **(C, D)**.

As you're finishing, adhere ink to the stamp and press it on a scratch piece of paper. This will allow you to see the stamp in action, which will point out areas that may need closer carves.

fig. A

fig. B

fig. C

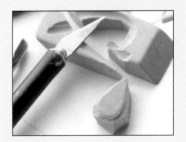

fig. D

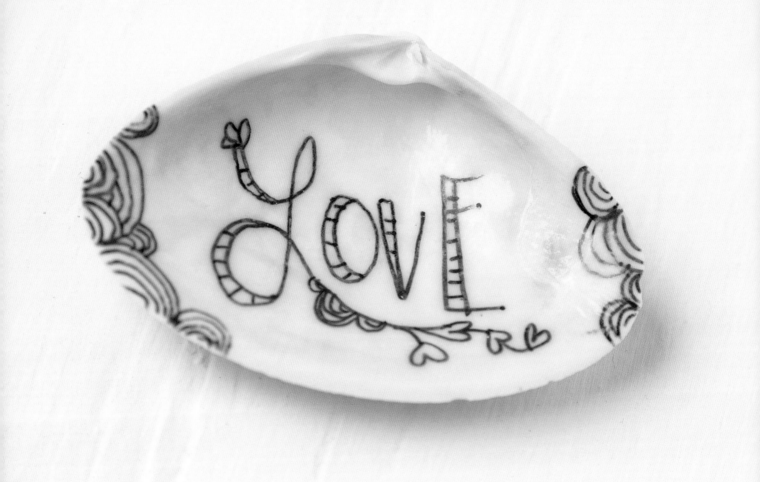

Jenny Sweeney

www.jennysweeneydesigns.com

I spent most of my childhood with my grandparents on their magical estate. I was an only child and my mother was a single mom so I was forced to entertain myself on a regular basis. I was always making arts and crafts, and I discovered early on my love for the handwritten word. I would write words and the alphabet over and over, and people started giving me compliments about my lettering. As an adult, lettering is a big part of my creative expression. I find it to be a true art form and it is something that can be specifically mine forever.

FAVORITE LETTER

I like the letter C because I can gently cradle other letters inside of it.

FAVORITE WRITING INSTRUMENT

I love black art pens. I think I have a couple hundred, all in different widths, though my favorite size tends to be the 0.1 mm.

Lettered Shells

I am a sun-loving beach girl. I absolutely love walking the beach in search of beautiful little sea treasures. I think there is so much beauty and imperfection in found objects. After collecting these imperfectly perfect shells during my beach walks, it became a natural progression to combine my love of lettering with them. They are easy to make and wonderful to give.

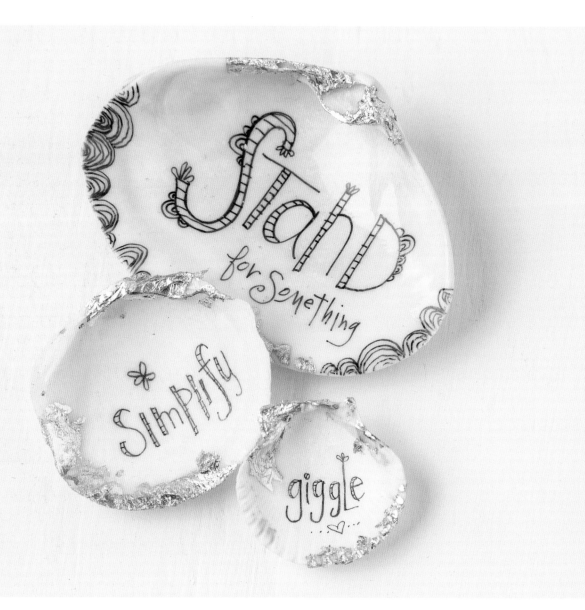

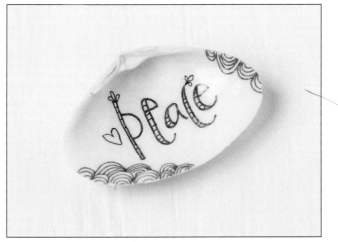

fig. A

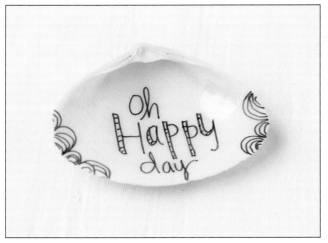

fig. B

fig. C

What You'll Need

* Shells with smooth interiors
* Black fine-point and extra-fine-point permanent markers
* Small paintbrush
* Gold leaf adhesive
* Sheet of gold leaf

Method

1 Wipe off any sand or dirt from shells and let dry.

2 Write a single word or phrase with a fine-point marker **(A, B)**.

3 Add closed counter form strokes to some of the letters and make tiny horizontal strokes to those closed spaces. Plump up certain parts of letters **(A, B)**.

4 Add doodles to the words and other parts of the shell with an extra-fine-point marker **(A, B)**.

5 Use the small paintbrush to apply a light coating of gold leaf adhesive on the edges of the shells. Be random and light handed in this process. You don't want too much gold leaf on the shell or it will overpower it.

6 Following manufacturer's instructions, apply a small amount of gold foil to the tacky adhesive and let dry. Lightly brush off excess foil **(C)**.

doodled alphabet

This alphabet is made with a combination of lowercase and uppercase letters. I think combining them makes words and phrases look playful. Each letter was made with a black fine-point marker and then closed counter form strokes were made on almost all parts of each letter. The spaces made with these added strokes are where I added tiny horizontal or diagonal lines. Next, I took an extra-fine black marker to add more doodles to the letters, like clusters of semi-circles, leaves, flowers, and swirls.

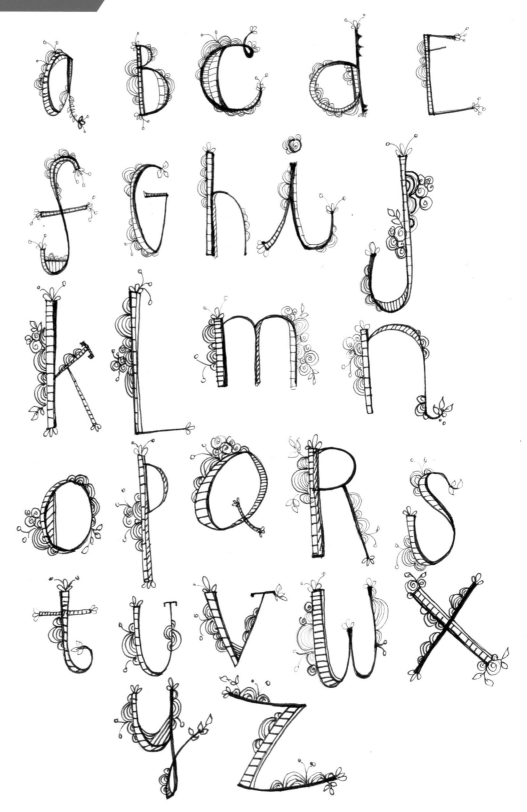

Using the methods described for my doodled alphabet, I lettered the word "Love" by stacking the first two letters on top of the last two letters.

I added lots and lots of doodles to make each letter, and ultimately the entire word came alive.

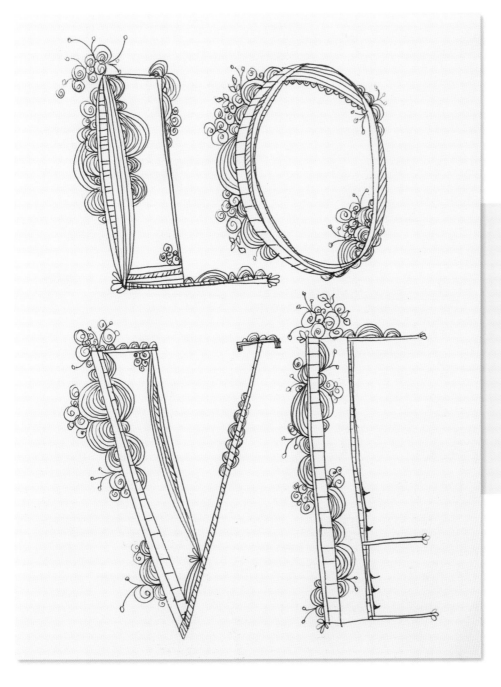

FAVORITES THROUGH MISTAKES

Some of my favorite letters have evolved out of mistakes. So if you are just starting out with lettering, I hope you make lots of mistakes, because that's how you'll find your favorites.

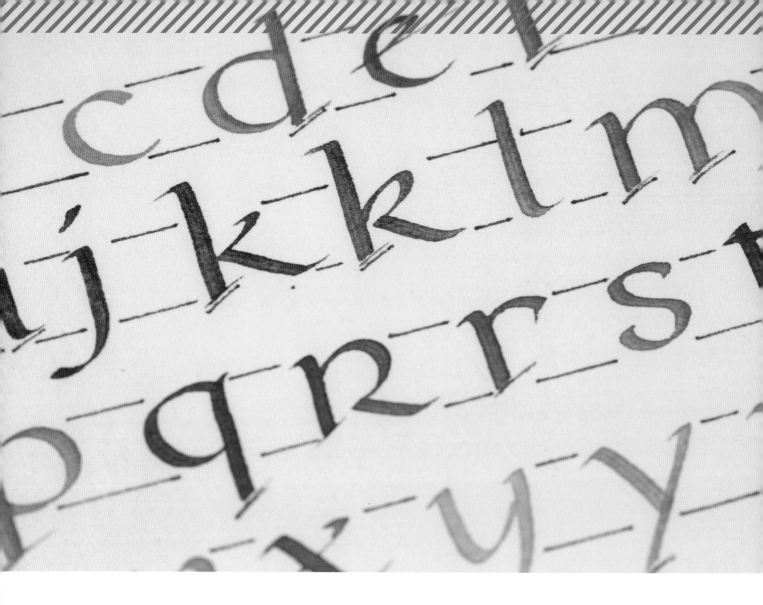

Deborah Gerwig Powell

My earliest memories of lettering involved the love of opening my father's desk to look at and try out his writing tools. He had stacks of business stationery and envelopes, carbon paper, red and blue pencils, erasers, pens, rulers, clips, and clamps. In my grade school days, I recall thinking I had to have one of those multiple color ballpoint pens that was shaped a bit like a fat bullet because it held red, blue, green, and black colors that could be switched by clumsily pushing a lever on the pen. It never worked very well or for very long but I thought it was the best pen ever for a while! I'm still a sucker for a new pen.

FAVORITE LETTER

My favorite letter could be any letter because it's usually the one that I have most recently struggled to create and am finally happy with. My least favorite letter is S because I struggle a lot with it but if I can manage to make a good one, it can also be my favorite!

FAVORITE WRITING INSTRUMENT

The Pigma Micron fine line pens are my favorite because they allow rapid writing and can be used to fill in tight spaces in a neat manner.

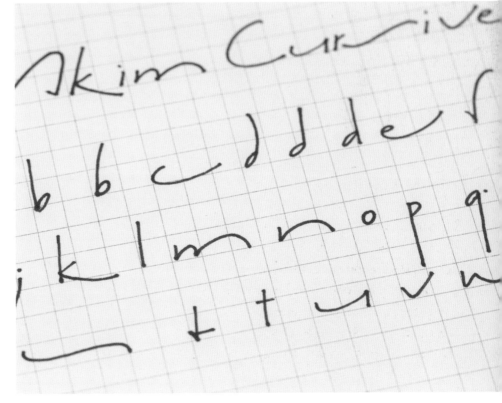

soft and subtle tags and card

With a white brush writer and PanPastels, you can create soft and subtle effects on paper that are simple and elegant.

- For the two tags, I first wrote letters with a white brush writer. If you don't have a brush writer, you could dip a small round brush into white ink to get a similar effect.
- Once dry, I applied PanPastels all over the tags. You can use just one color or multiple colors. *Note: PanPastel is an art medium made of powdered pigment that comes in a small round plastic container. A small artist sponge is used to load the pigment from the PanPastel and then applied to the substrate.*
- For the "P" on one of the tags, I drew the outline of the letter on a tag, used a dark brush marker to letter all over, and then applied PanPastels over the lettering. Then I cut the "P," punched a hole at the top, and attached it to the background tag.
- For the PanPastel baby card, I lettered the word with a white brush writer and then rubbed pink PanPastel all over the front of the card. I lettered on a skinny strip of patterned paper with a fine-point black marker and attached that to the card with a button and string.

THANK HEAVEN FOR LITTLE GIRLS!

The foundational hand was developed in the early 20th century and can be achieved with a basic calligraphy nib. These letters have thick downstrokes, thin upstrokes, and are written straight up and down without a slant. To add a contemporary twist, take a fine-point marker and add imperfect squiggles to the letters. The squiggles can be made all around a letter, just on the right and bottom sides, just the left and upper sides, or whatever combination you like.

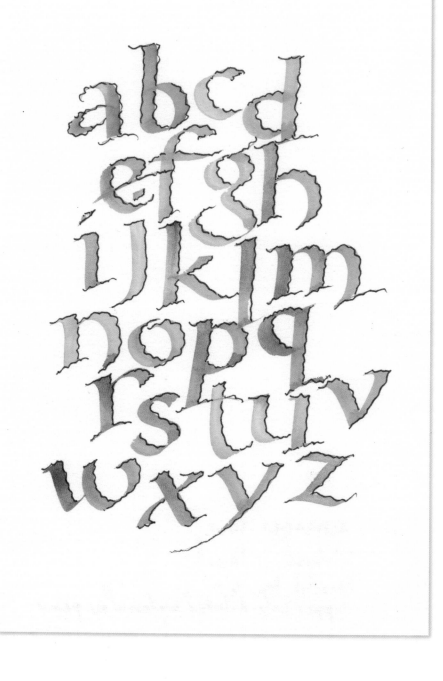

The Akim Cursive is also a popular hand among calligraphers. It is a monoline script, with each letter created with clean, single lines without any drop shadows or serifs. Once you get the gist, you can create variations to make it uniquely your own by exaggerating certain strokes, omitting others, or adding an extreme slant to some. Akim Cursive letters are great to use in conjunction with chunkier hands, to create interest.

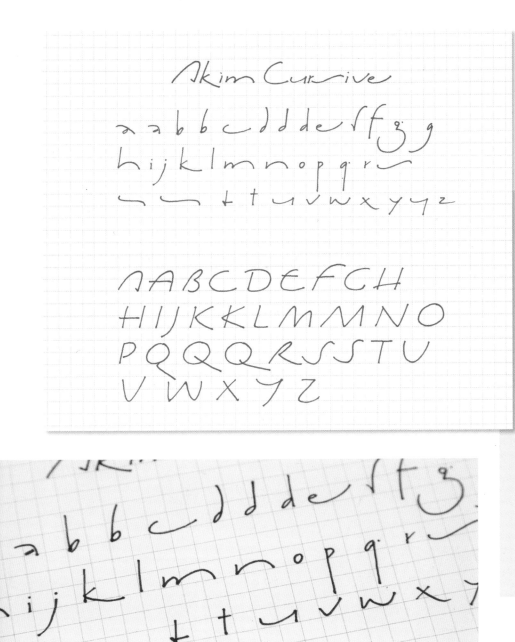

PERSONALITY OF THE WRITER

I find hand lettering involves the senses, evokes memories, requires concentration, and stimulates language skills. Even though our world moves faster in this digital age, sometimes it is worthwhile to take the time to reflect, digest, and assimilate. Hand lettering shows the personality of the writer and reflects the care given to communication with another human being.

tag, you're it

To make the "to you" tag, I used black markers in assorted nib widths to letter the words in many different sizes. There's no right place to start, really. Just begin wherever you want with whatever size pen you like, varying the size and weight of lettering across the tag, going off the page, changing styles as you go. Change the leading of the lines as you go, alternating from uppercase to lowercase letters. For the lighthouse invitation tag, I combined block letters with the Akim Cursive alphabet to make the scant amount of writing. A postage stamp, decorative papers, and ribbon were used to pull together a piece that is minimal and handsome.

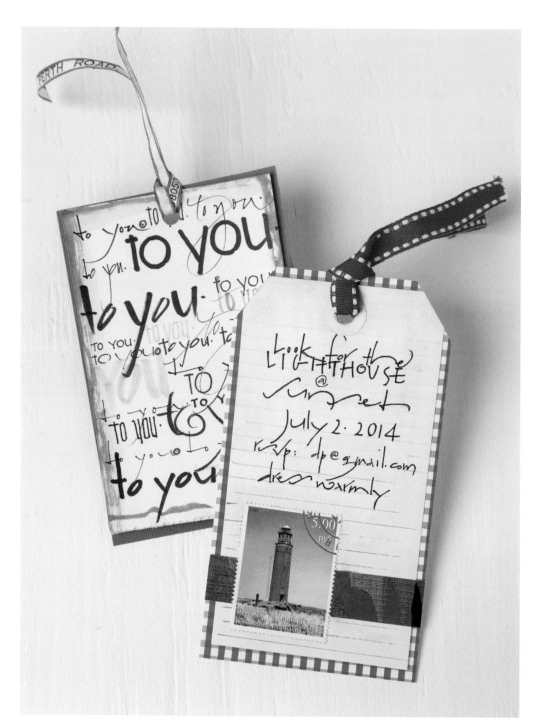

CONSISTENCY OF HAND

For those who are frustrated about their lettering, appreciate that you know the difference between good and better. Don't be afraid to use exemplars to trace over until you have a sense of the style you are trying to master. Eventually you'll have developed your own variation and consistency of that hand.

Rosaura Unangst

www.pigmentandparchment.com

The first person who inspired me to start hand lettering was an art nerd on whom I had a massive crush. He was an amazing graffiti artist whose work got my interest piqued. Then, once I was 19 years old and working as a sign artist at Trader Joe's, I was hooked.

FAVORITE WRITING INSTRUMENT

The writing instrument that has been a constant in my life is the trusty Micron pen. I never have fewer than three in my purse so I can draw at a moment's notice. They're archival, waterproof, and there's nothing like the thin line of the size .005 mm Micron.

FAVORITE LETTER

The capital L has been a favorite since I learned it in the third grade. All those loops are just too much fun.

Funky Masked Alphabet

It took a year of trying various techniques and different brands of tools and supplies before I discovered a wonderful process using drawing gum and a ruling pen. When paired together, I have the maximum amount of control in dispensing very thin lines of masking medium. It's perfect for making this funky alphabet.

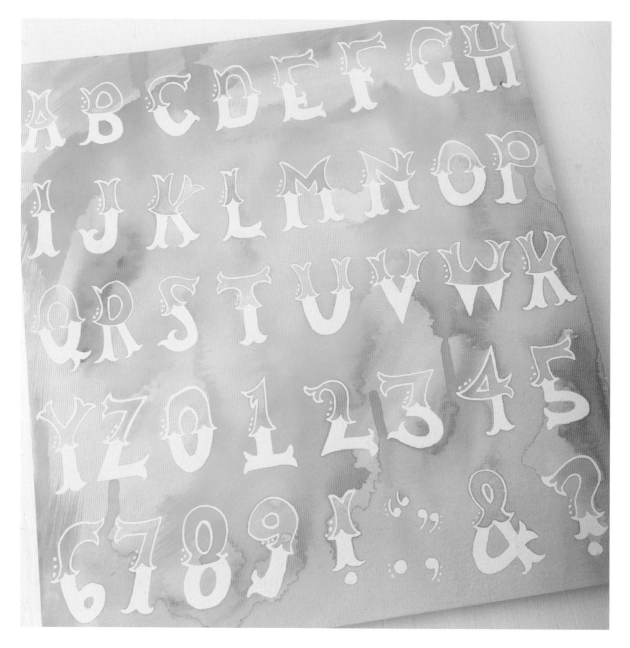

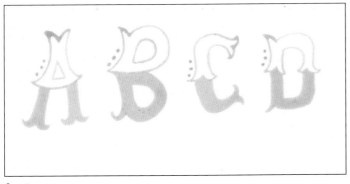

fig. A

fig. B

What You'll Need

* Heavyweight watercolor paper
* Ruling pen
* Pebeo drawing gum
* Cup with water
* Watercolor brush
* Watercolors
* Rubber cement pick-up

Method

1 Adjust the knob on your ruling pen to open the two prongs to the desired width. The more open the prongs are, the heavier and thicker the line weight will be.

2 Dip the ruling pen into the drawing gum. Allow excess fluid to drip back into the jar.

3 Draw a letter from the alphabet onto the watercolor paper, noting the curly and pointy flourishes at the ends and middles of each uppercase outlined letter. Fill in the bottom half of the letter with the drawing gum. Note: Keep dipping the ruling pen back into the drawing gum jar, just as you would with calligraphy ink. Make sure both prongs touch the paper every time you make a mark, to ensure that the line weights are as even as possible **(A)**.

4 Let the drawing gum dry completely. When it is dry, the gum will darken in color while becoming more transparent. Repeat with all other letters.

5 Use the wet into wet method to add color to the paper:
 * Use a watercolor brush to apply water over the entire paper
 * Add two or three watercolors all over the wet paper.
 * Pick up the paper and tilt it in various directions to get the drippy and swirly effect. Let the paper dry **(B)**.

6 Use a rubber cement pick-up (or your finger) to remove the drawing gum. To avoid snags, be slow and gentle with this process.

the opposite of war

I love using lyrics as inspiration for creative lettering as I have done for this piece. I tend to not map out what I'm doing before I do it. I just play with composition and space and see where my letters and doodles take me.

I used an oblique pen holder and nib with black ink to just start writing the words for this piece. I used different fonts, lines, and embellishments to come up with an overall composition that keeps the viewer's eyes moving around the page. Next, I filled in areas that I felt were empty with doodles. Finally I added color with watercolors and gouache. *Note:* Watercolor is transparent and can be used over lettering. Gouache is opaque and should not go over lettering.

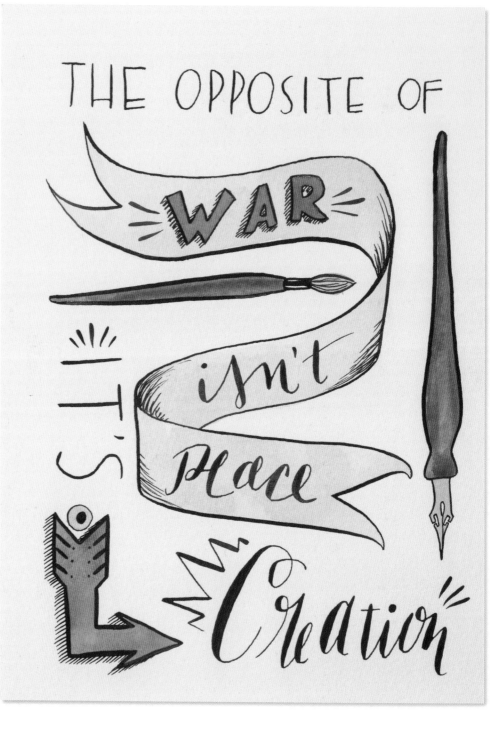

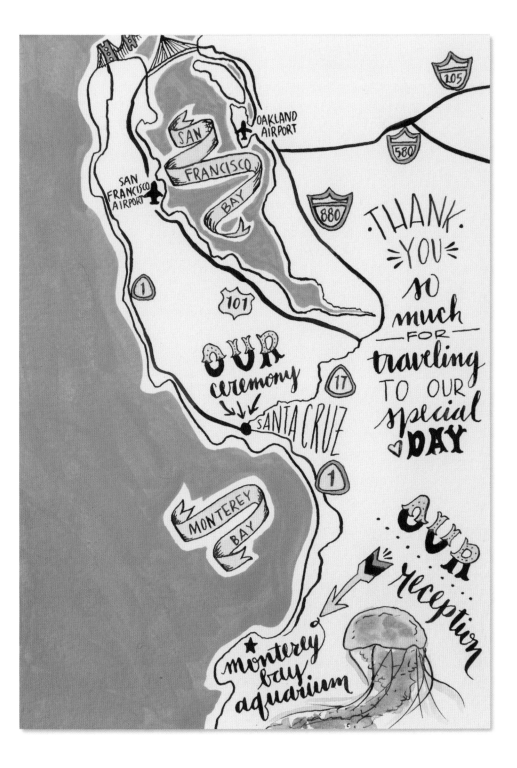

There is something magical about handmade maps. The first step is to illustrate the main lines of your map. This includes the main shape of the area you are drawing, and any freeways, highways, rivers, lakes, bridges, and such. Remember that less is more when it comes to making maps so if the information isn't important, edit it out.

Start filling in titles of streets, highways, and main points of interest. Once the main parts are labeled, add any banners or titles. Look for spots on the map that look a bit empty and doodle away! Once the ink is dry, start painting your map with watercolors and/or gouache. If you're adding watercolor over any of the inked areas, use a small amount of water and move quickly or else it will reactivate the ink and cause it to start bleeding and mixing. Keeping white borders between the ink and paint is easier, and also makes those areas pop!

Michael Mullan

www.mullanillustration.com

My fifth grade teacher always gave extra credit to students for turning in drawings. I was really into sports at that age and remember always trying to replicate my favorite team logos. I got pretty good at knocking off the Chicago Cubs and Bulls logos and remember really enjoying the act of intentionally replicating a letterform that was purposely imperfect — exactly as I do now!

FAVORITE LETTER

My favorite letter is actually a symbol: the ampersand. I love it because it is very distinct and ties hand-lettered words together beautifully. The curves are playful and almost humorous when drawn by hand.

FAVORITE WRITING INSTRUMENT

The OptiFlow pen from Staples is my favorite. The ink in this rollerball just pours out of the nib so nicely.

Lettered US Map

Typically, I like to vary line weights and font styles in my work. For this project, however, I used an even line weight to keep the emphasis even from state to state. Though it's a time-consuming process, making a lettered US Map is not as complicated as it might seem.

THE UNITED STATES of AMERICA

SHINGTON ID MONTANA NORTH DAKOTA minne SOTA Wisc onsin MICHI GAN ma ine

GON A HO Wyom ing south Dakota IOWA ILLIN OIS INDIANA Ohio PENNSYLV new

NEV ADA UTAH COLO RADO NEBRASKA miss ouri KENTUCKY UV VIRGINIA MARYLAND

ARIZ-new OKLA HOMA Kansas ARKAN SAS Tennesse north carolina

ONA mexico TEXAS ALABAMA GEO RGIA south Carolina

MISS ISS ippi FLOR I

Louisiana

N
W E
S

ALASK A

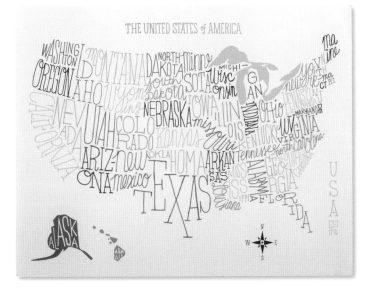

What You'll Need

✳ Printout of a US Map, sized to fit a 14 x 11 inch (35.6 x 27.9 cm) illustration board
✳ Light box or well-lit window
✳ Masking tape
✳ Sketchbook paper
✳ 2B Pencil
✳ Compressed charcoal
✳ White heavyweight hot-press paper, 14 x 11 inches (35.6 x 27.9 cm)
✳ Fine-point rollerball markers in assorted colors
✳ Kneaded eraser

Method

1 Place the print of a US map on the light box or on a brightly lit window and tape it in place with a piece of masking tape. Tape a piece of sketchbook paper on top of the map and lightly outline all of the states with a pencil.

2 Rub a thick layer of compressed charcoal on the backside of the sketchbook paper.

3 Place the sketchbook paper, charcoal side down, on the heavyweight paper. Using a pencil, draw over the original sketch. This will cause the charcoal to transfer an impression of the sketch onto the paper.

4 Using a pencil, letter the names of each state within the space for each state. Retrace over the pencil lettering with fine-point markers in assorted colors.

5 Using a kneaded eraser, erase the charcoal marks.

I love the quote and optimism that this piece conveys. I used digital media to scan my pencil sketch and then add color to the letterforms. An alternative to using digital media would be to use a sharp craft knife to cut the sketched letterforms from your paper. Fill in the cut shapes with watercolor, charcoal, or your preferred medium and then adhere the cut letters onto a final piece of paper.

I think each letter of this alphabet has a fun and funky personality. As a collection, the personalities work well together. I used a combination of uppercase and lowercase letters and did a variety of treatments including ornate serifs, block letters with dots, letters with shadows, and simple lines. After sketching the letters with a pencil, I scanned them and added color to them in Photoshop. You can do the same or you can add color with markers or a small paintbrush and watercolors.

Jenny Doh

www.crescendoh.com

I was born in Korea and lived there until I was seven years old, so my first memories of lettering are related to the 24 characters that create combinational character blocks of Korean words. When I moved to the United States, I learned a whole new batch of letters to create English words. Working with either the Korean characters or the English alphabet, I have always adored the act of making letters look their best.

Among the differences that I see between Korean and English letters is that for the most part, Korean characters do not contain upstrokes. They are all down, horizontal, or downward diagonal strokes. All letters, for me, are as much about their inherent qualities as design elements as they are marks that construct words with definitions. Marks that look like letters but have no true legibility and therefore no true definitions are exciting for me to create and observe.

FAVORITE LETTER

My favorite is the letter M. I like the flourish that the letter can start with both in lowercase and uppercase. I like that the uppercase M can be made to look smooth and curvy or straight and angular.

FAVORITE WRITING INSTRUMENT

These days, my favorite writing instrument is an eye dropper. I like to load it up with acrylic ink and make my letters.

I Volunteer as Tribute

Lettering on Plexiglas gives me a cool effect. When combined with doodled collage and wood, it becomes super cool.

fig. A

fig. B

fig. C

What You'll Need

* Book page
* White gesso
* Foam brush
* Wooden skewer
* Black and red acrylic inks with eye droppers
* Glue dots
* Wood panel, 8 x 10 inches (20.3 x 25.4 cm)
* Plexiglas, 8 x 10 inches (20.3 x 25.4 cm)
* Working fixative
* Hand drill
* Four small nails
* Hammer

Method

1 Apply a coat of white gesso to a book page with a foam brush. Let dry.

2 Doodle a bow and arrows onto the book page with acrylic inks and eye droppers. Let dry **(A)**.

3 Attach the paper onto the wood panel with glue dots.

4 Place the Plexiglas on top and letter the words with an eye dropper so they fit below the encased paper. Use a wooden skewer to move the ink around or add squiggles to the lettering. Let dry **(B)**.

5 Spray the Plexiglas with working fixative.

6 Use a hand drill to make holes at all four corners of the Plexiglas. Do not drill into the corners of the wood. Attach the Plexiglas by centering it on top of the wood and hammering four small nails through the holes of the Plexiglas and into the wood **(C)**.

inky alphabet

Many acrylic inks come in small jars with an eye dropper attached to the lid. That is what I used to make this alphabet. If you want to use inks that do not come in these sorts of bottles, you can buy an eye dropper or a pipette separately and make the letters. You'll want to experiment with the dropper to see how to control the amount of ink you let come through. The harder you squeeze, the more ink will come out, and at a higher speed, than if you squeezed very lightly.

This method makes basic script letters look extremely imperfect and slightly spooky, and every person's hand will produce a slightly different result. For added interest, I took a wooden skewer and made scribble motions on the left-most section of the letters while the ink was still wet. When you are working with inks and droppers and don't want the inks to run, make sure that you are working on a completely flat surface and allow the ink to dry completely before handling the work.

lettered magnolia leaves

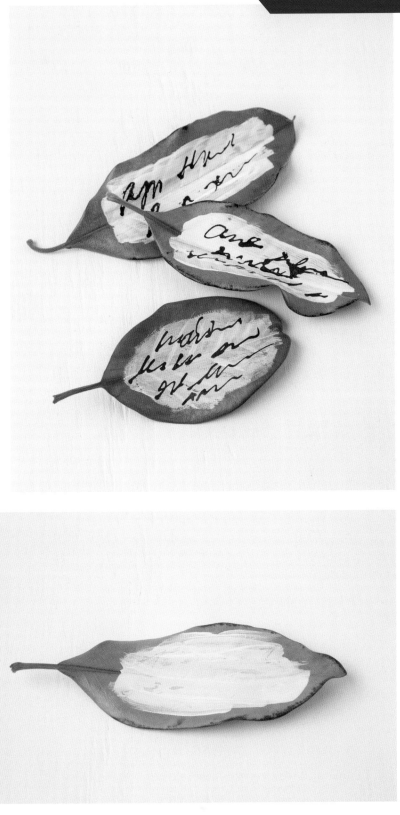

I'm lucky to live on a street that is lined with magnolia trees. The leaves that fall from the tree are beautiful. To make these lettered leaves, first wipe off any dirt or residue from the fallen leaves with a wet paper towel and let dry. Apply a coat of white gesso onto the leaves with a foam brush. Let dry. Use an eye dropper and acrylic ink to letter words, or names, or scribbles that emulate letters. Use a wooden skewer to move the ink around.

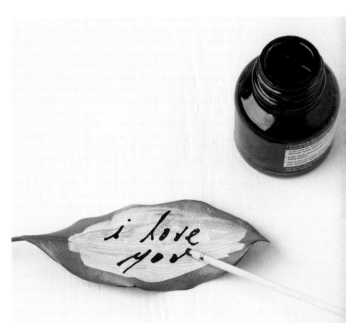

About the Contributors

LINDSEY BUGBEE is a calligrapher and designer who founded The Postman's Knock, a lettering company. Her goal is to create beautiful, unique wedding paper goods. She also maintains a vibrant blog on her site where she provides readers with tutorials and inspiration. Visit www.thepostmansknock.com

LISA CONGDON is an artist and illustrator best known for her colorful collages. In addition to illustrating full time, Lisa writes a popular daily blog of her work, life, and inspiration called "Today is Going to be Awesome." She is author of *Whatever You Are, Be a Good One*, and *Art Inc*. Visit www.lisacongdon.com.

JENNY DOH is in love with making art. She is head of Studio Crescendoh in Santa Ana, California, where she teaches painting and fiber arts. The studio also hosts visiting artists who teach painting, art journaling, and more. She has authored and packaged numerous art and crafting books. Visit www.crescendoh.com.

DIANE HENKLER loves all things creative, colorful, and DIY. Through her work as a creator of displays, Diane became drawn to the unique, imperfect, and one-of-a-kind items. She shares her ideas on lettering and DIY projects on her blog, www.inmyownstyle.com.

After many fun years in advertising, **KRISTINE LOMBARDI** decided in 2003 to pursue illustration on a full-time basis. She works primarily in gouache and ink, often with bits of collected ephemera that she layers into her work. Visit www.kristinelombardi.com.

Since 1995, **ROANN MATHIAS** has been teaching workshops for calligraphy guilds and at conferences throughout the United States and Canada. In addition to calligraphy, Roann teaches classes geared for visual artists at mixed media conferences. Visit www.roanndesigns.com.

MICHAEL MULLAN is a Vermont-based illustrator who lives in a cabin on a hill, between a farm and a sugar shack. He is originally from Chicago but enjoys the freedom that comes with small town living. Michael is inspired by everything folk — the art, the music, and the tales. Visit www.mullanillustration.com.

APRIL NEMETH is founder of Little Korboose, a design and illustration shop that reflects April's keen eye toward modern and eco-friendly products. April's love for simple, clean design is showcased in her playful and sweet works of art. Visit www.littlekorboose.com.

DEBORAH GERWIG POWELL is a lover of letters, words, and textures. She teaches workshops on lettering and works as a freelance

calligrapher. Deborah does not have a website but welcomes email at dgp2ink@yahoo.com.

LEANDRO SENNA was born and raised in São Bernardo do Campo, Brazil where he earned his BFA in graphic design. After working eight years as a designer of packages, Leandro moved to New York City and then to San Francisco where he currently lives, works, and pursues new adventures. Visit www.leandrosenna.com.

For many years, **ALEXANDRA SNOWDON** worked as a studio-based graphic designer. The lessons she learned about typography through this work remain invaluable to her in her current work as a freelance illustrator, hand letterer and printmaker. Visit www.snowdondesignandcraft.com

JENNY SWEENEY is an artist who loves animals, design, and travel. She has a playful stationery line that is sold across the country in stores like Papyrus, Paper Source, and Neiman Marcus. Jenny also creates custom invitations for her many clients. Visit www.jennysweeneydesigns.com.

ROSAURA UNANGST has devoted her life to creating, learning, and seeing. She teaches workshops and creates commissioned artwork for weddings, events, and businesses. Visit www.pigmentandparchment.com.

As a full-time artist, **MEGAN WELLS** delights in the fact that she gets to make things all day long. When she is not lettering or illustrating, Megan paints portraits, cooks, runs, and spends time with her husband. Visit www.makewells.com

KERRI WINTERSTEIN is a twenty-something wife, mama, and creative soul. She currently divides her time between dreaming up new products for her Etsy shop, living the adventures of mommyhood, and striving for simplicity. Visit www.yourwishcake.com.

Editors: DEBORAH STACK, JILL JARNOW, AND LINDA KOPP

Technical Copyeditor: NANCY D. WOOD

Assistant Editors: AMANDA CRABTREE WESTON, AND MONICA MOUET

Designer: RAQUEL JOYA

Photographer: CYNTHIA SHAFFER

Index

ABOUT THE AUTHOR

Jenny Doh has authored and packaged numerous books including *Washi Wonderful*, *Crochet Love*, *Craft-a-Doodle*, *Print Collective*, *Creative Lettering*, *Stamp It!*, *Journal It!*, and *We Make Dolls!*. She lives in Santa Ana, California, and loves to create, stay fit, and play music. Visit *www.crescendoh.com*.